IMAGES
of America

MALIBU

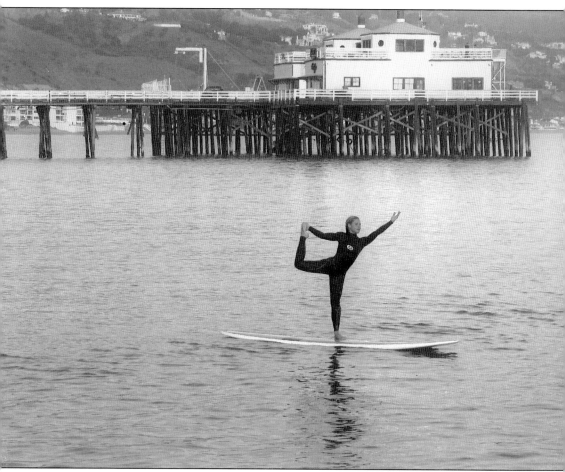

"GOLDEN HOUR." Golden hour is a photography term for the time of day when slanting sunlight creates natural lighting effects that no amount of special-effects money can buy. This is Alex "Aflex" Westmore busting a yoga move on the author's 12-foot, 1-inch Laird Surftech stand-up paddleboard. The photograph was shot at golden hour on a November afternoon, framed by the Malibu Pier and the refreshingly empty hills of Malibu. (Courtesy Ben Marcus.)

ON THE COVER: A bevy of boss beach babes gaze out to sea in a production shot from *How to Stuff A Wild Bikini*—one of many American International Pictures "waxploitation" films made on the beaches of Malibu in the 1960s. (Courtesy Marc Wanamaker/Bison Archives.)

IMAGES
of America

MALIBU

Ben Marcus and Marc Wanamaker

ARCADIA
PUBLISHING

Published by Arcadia Publishing
Charleston, South Carolina

Printed in the United States of America

Library of Congress Control Number: 2011926200

For all general information, please contact Arcadia Publishing:
Telephone 843-853-2070
Fax 843-853-0044
E-mail sales@arcadiapublishing.com
For customer service and orders:
Toll-Free 1-888-313-2665

Visit us on the Internet at www.arcadiapublishing.com

*This book is dedicated to the Chumash Indians, Frederick
and May Rindge, the Adamson family, and all the citizens
and politicians public and private who love Malibu and
have fought to protect it from getting all screwed up.*

CONTENTS

ACKNOWLEDGMENTS

Special thanks to Nate White at the Levi's store for the initial idea, Jerry Roberts, Tiffany Frary, my patient and marvelous editor Debbie Seracini, Marc Wanamaker, Brian Rooney, Morgan Runyon, Lou Busch Jr., Jefferson "Zuma Jay" Wagner, Glen Howell, Marshall Coben, Kelsey Lee Ann Martin, Mike Malone, Curtis Beck, Rich Leo, Bob Morris at the Beach Cafe, Bob Feigel, George Trafton, Jim Fitzpatrick, Josh Morgan, and Kathy Kohner-Zuckerman. Thanks to Bill Miller and the Malibu Kitchen crew for the workspace and the hot water, and also thanks to the groovy guys and girls at Starbucks Colony Plaza for the WiFi and the juice. Thanks to Janet Macpherson and Steven Farbus for the toolshed and Sue Peck for the lot. And thanks to Morgan for a taste of the Old Place. All images used in this book come from Marc Wanamaker unless otherwise noted. Thanks to Ned Evans for the Andy Lyon cutback and Bryan Rooney for the Old Place photograph.

INTRODUCTION

From the Chumash people to the television show M*A*S*H and before and after, Malibu has been a 23-mile strip of scenic beauty between the Santa Monica Mountains and the deep blue sea—a naturally blessed slice of Los Angeles County with a long history that goes back to a time when the Chumash named it Humaliwo, which means "where the surf sounds loudly." This place of perfect weather and easy living was as prized by the Native Americans as it is now by the rich and famous, who live in million-dollar homes along the beach or up in the mountains. Malibu is a place blessed with surf, sun, and a near-perfect Mediterranean climate.

The place where the surf sounds loudly is at what was the southern border of Chumash territory—a lagoon at the end of the creek that flowed out of the mountains and brought sand and gravel down from the hills, forming a lagoon and sand point. Life was not as nasty, brutish, or short for the Humaliwo Chumash as it was for other Native American tribes. They lived under a benign climate, at the end of a freshwater source, and lived on a steady food supply from land and sea. They ate deer and elk, acorns, birds from the lagoon and from the sea, and a "Malibouillabaisse" of lobster, abalone, rockfish, and swordfish.

Chumash life was relatively easy, and they had the time and leisure to develop their arts and crafts to a high level of sophistication. Chumash baskets were woven so tight that they could add water, fish, and hot rocks to make a primitive Cup-a-Soup.

The Chumash *tomol* (canoe) was a wonder of pre-European-contact technology. Fast and sturdy, the tomol could be used to hunt swordfish or take more than a ton of trade goods up and down the coast, traveling all the way out to the Channel Islands, a part of the Chumash domain.

The Chumash lived la dolce vita along Humaliwo Creek for centuries until the horizon became filled with the billowing sails and the tall ships of the Spanish, who first visited California in 1542, only 50 years after Columbus sailed the ocean blue and discovered the New World. In 1542, Juan Rodriguez Cabrillo went ashore to fill his water casks at a place he called Pueblo de las Canoas, Spanish for "village of the canoes" because of all the canoes that greeted his ships. Cabrillo found all the freshwater he needed, and he also found healthy, friendly natives living the good life at the mouth of Malibu Creek (although some argue whether that landing was at Humaliwo).

The Spanish came, they saw, and they slowly conquered the place they called California. After that first contact with Cabrillo in 1542, the Europeans mostly ignored that sunny corner of California until 1776, when an expedition lead by Juan Batista de Anza was moving north through what is now the San Fernando Valley. On February 22, 1776, the Anza expedition camped near water in a place that could have been the same location where the television show M*A*S*H was filmed 200 years later. It is said that a 14-year-old member of the Anza expedition, Jose Bartoleme Tapia, rode his horse along an Indian trail through Malibu Canyon, got a look at Humaliwo, and saw that it was good territory.

Some people argue with the story, but there is no arguing that at the turn of the century, around 1802, the commander of the Santa Barbara Company, Don Felipe Goycoechea, gave Jose Bartoleme Tapia the Rancho Topanga Malibu Sequit, a place where Tapia could keep his grazing stock.

This began the transition of the land from Humaliwo to Rancho Malibu. The original land grant for Rancho Topanga Malibu Sequit is thought to have been as large as 50,000 acres, going from Las Flores Canyon to well past the current Ventura County line and all the way to Calleguas Creek, which empties into Mugu Lagoon. Bartoleme Tapia worked Rancho Malibu with his wife and as many hands as he could muster when Southern California was still one of the ends of the earth. Tapia died in 1824 and left all the land to his wife.

On the Fourth of July in 1847, the 15-year-old granddaughter of Jose Bartoleme Tapia and Maria Francisca Villalobos-Tapia married a 24-year-old Frenchman named Leon Victor Prudhomme. Six months later, Leon Victor and Maria Merced Tapia-Prudhomme signed a lease, taking control of Rancho Malibu in exchange for 400 pesos. This exchange happened on January 24, 1848, which was coincidentally the same day gold was discovered at Sutter's Mill in Coloma, California.

That was good and bad timing for Prudhomme. The beef, leather, and other produce of Rancho Malibu were worth a fortune in the gold fields, and the ranch prospered during the Gold Rush that began in 1848. But 10 days after Prudhomme signed the lease and gold was discovered, Mexico and the United States signed the Treaty of Guadalupe Hidalgo, ending the Mexican-American War. California fell under the control of Uncle Sam, and in the legal wrangling to prove the claims of Spanish and Mexican landowners, Prudhomme was forced to sell Rancho Malibu for 10¢ an acre, equaling $1,330, in 1857 (the equivalent of $30,000 today). However, others say Prudhomme let the land go to vintner Don Matteo Keller to pay off an unpaid wine bill.

Don Matteo Keller was an educated Irishman who studied for the priesthood and came to California by way of Mexico. He began raising grapes and pressing wine in Los Angeles around 1851 and is now known as one of the godfathers of winemaking in Southern California, which is a possible explanation why an Irishman referred to himself as Don Matteo.

Keller ran Rancho Malibu as a somewhat absentee owner until his death in 1881. His son Henry Keller took over and had himself deputized to legally control the rustlers, poachers, and squatters who were making inroads onto his land. In 1892, Deputy Sheriff Henry Keller was in Santa Monica and went to the scene of a bar fight. He walked in with a shotgun and mistakenly shot and killed the bar owner Charles Kimball by accident. Keller was cleared of wrongdoing. But in that same year, the 21-year-old heir to Rancho Malibu found a willing buyer, Bostonian Frederick Hastings Rindge. What Don Matteo Keller had bought for 10 cents an acre in 1857, Henry Keller sold for $10 an acre in 1892, which was a 1,000 percent increase for Keller and a good deal for Keller and Rindge.

Frederick Hastings Rindge was the son of a prominent Boston Puritan family. All of his brothers and sisters died of scarlet fever. He attended Harvard University with Teddy Roosevelt in the late 1870s. In 1883, after the death of his father and later his mother, Rindge inherited a textiles and real estate fortune worth an estimated $3 million ($70 million today).

Rindge was eager to go west to grow with the country, but before he left he endowed three buildings in Cambridge: the public library, the city hall, and a manual training school now known as Cambridge Rindge and Latin School, the alma mater of Ben Affleck, Matt Damon, and many other prominent Bostonians.

Rindge came to the West Coast in the 1880s for his health and for opportunity. One of his first acts was to promise to reimburse the City of Santa Monica any lost revenue if it closed all the saloons; that worked for about a year. In Southern California, Rindge founded the Conservative Life Insurance Company, which is now the Pacific Life Insurance Company. He was a vice president of Union Oil and a director of the Los Angeles Edison Electric Company, which is now Southern California Edison. He had investments from Northern California to Sinaloa, Mexico, but his purchase of Rancho Malibu fulfilled his desire for "a farm near the ocean and under the lee of the mountain, with a trout brook, wild trees, a lake, good soil, and excellent climate."

Rancho Malibu fulfilled all of these requirements, and the 13,300 acres that stretched from present-day Duke's Malibu to Neptune's Net was a working cattle ranch where Rindge also grew lima beans, barley, citrus, and other produce for a growing market that was 10 miles down the coast.

Frederick Rindge died unexpectedly in 1905 after being in a diabetic coma and left his entire estate to his wife, Rhoda "May" Knight Rindge, a schoolteacher from Michigan who he had married in 1887; they had three children. Reported in the *Los Angeles Times* in 1905, May found herself the beneficiary of an estate valued at $22 million—the modern equivalent of half a billion dollars.

May Rindge did not go to Harvard with Teddy Roosevelt, and nothing in her 40 years had prepared her for such a burden. She could have easily sold the Malibu Rancho and all the stocks and the holdings her husband had accumulated. Instead, May chose to fulfill her husband's wishes that included maintaining Rancho Malibu as a private enclave, slowly transforming it into the California Riviera.

Beginning in 1907, May Rindge fought in an endless chain of court cases against the Southern Pacific Railroad, her neighbors, federal homesteaders, illegal squatters, the Cities of Venice and Santa Monica, the Counties of Los Angeles and Ventura, the State of California, and eventually the United States of America. What had once been lonely cattle land was becoming ever more valuable as California grew, and through the first 20 years of the 20th century, May invested a great deal of the Rindge estate in lawsuits to fight off the intrusion of a county road and then later a state highway.

She wasn't going to win, but she wasn't going to quit, and in 1923 the Supreme Court made a fundamental eminent domain decision in *Rindge Company v. County of Los Angeles*. Yes, the Malibu was private property, but the county did not really have a right to build a road connecting Los Angeles and Ventura Counties; unfortunately for May Rindge, the court ruled in favor of a greater public good.

After the Supreme Court decision, Rindge continued to fight endless court cases over every little detail while she planned for the inevitable. In 1925, the *Los Angeles Times* reported that Rindge hired Mark Daniels: "Former assistant secretary of the interior and architect who landscaped Yosemite and other national parks, has been retained to zone and subdivide the Malibu rancho, according to an announcement made yesterday by Mrs. May K. Rindge, president of the Marblehead Land Company."

Construction of the two-lane paved highway through Malibu began the next year. The Malibu Pier was extended also in 1926 to accommodate a pleasure yacht—the 99-foot *Malibu*—purchased by the Rindges and the Adamsons.

In 1928, the *Los Angeles Times* reported, "Tremendous increase in the value of land has taken place on the Malibu, which once changed hands because of the failure of its second owner to pay a grocery bill of less than $1,000. The price of $10 an acre paid by Frederick Hastings Rindge in 1890 was thought ridiculously high. Now $5,000 an acre, or nearly $100 million for the entire rancho, is held to be a conservative estimate of its worth." The land that Frederick Hastings Rindge had paid $300,000 for in 1892 was now worth $100 million—the equivalent of $1.2 billion today.

May Rindge was smart; she never sold any of the land in the Malibu Rancho. She leased it instead, and one of the first areas offered became a strip along the beach near the lagoon the Chumash called Humaliwo. James M. Cain described what happened next in the article "The Widow's Mite" for *Vanity Fair* in 1933: "And then, in 1927, history was made in one fell swoop. Miss Anna Q. Nilsson rented a lot. This may not sound like history, yet in fact, it is. For Miss Anna Q. Nilsson was a moving-picture actress, and it is a peculiarity of moving-picture actresses that as soon as one of them does something, all the rest do exactly the same thing, not stopping to reason why. You might think this would keep them hopping around at a lively rate, but it doesn't, for it is not often that one of them thinks up something, or even thinks. Miss Anna Q. Nilsson rented a lot, and then Miss Marie Prevost rented a lot, and then a dozen more of them rented lots, and then some actors rented lots, and some supervisors. So Malibu Beach was going over with a bang, and the question of the bond issue, at any rate, eased up quite a bit."

In the end, the best-laid plans of May Rindge were turned to dust by the Black Friday stock market crash of 1929 and the Great Depression it triggered. Somehow, all the land, stocks, businesses, and other assets May Rindge controlled in the Rindge Estate and the Marblehead Land Company crumbled to nothing. By 1935, she was bankrupt.

On March 12, 1941, the *Los Angeles Times* reported the death of May Rindge and the abruptness of her will. Written entirely by hand, Rindge's will stated, "In the name of God, Amen, I May K. Rindge, being of sound mind, wish to dispose of my property in the following manner, if I have anything left. To my daughter Rhoda Rindge Adamson and my grandson Frederick H. Rindge II, who has lived with me since before he was 2 years old and is like a son to me, I bequeath all I have share and share alike. And to all others who would lay claim to my property I give one dollar."

The death of May Rindge also ended the era of Malibu as a Rancho—an era that went back to Jose Bartoleme Tapia riding with the Anza expedition of 1757.

One

RANCHO TOPANGA MALIBU SEQUIT
1802–1929

FREDERICK HASTINGS RINDGE (1857–1905). After the Chumash, Humaliwo became Malibu as it was owned and molded by Jose Bartoleme Tapia, Leon Victor Prudhomme, Don Matteo Keller, and then the man in this photograph, Frederick Hastings Rindge. The sole survivor of a prominent, wealthy Boston family, all five of his brothers and sisters died of scarlet fever. Rindge attended Harvard University with Teddy Roosevelt and inherited in 1883 a real estate and textiles estate worth $3 million. He endowed several buildings in the Harvard/Cambridge area and then married Michigan schoolteacher Rhoda "May" Knight in 1887. They went west to grow with the country. The climate of Southern California agreed with Frederick, and he looked for "a farm near the ocean and under the lee of the mountain, with a trout brook, wild trees, a lake, good soil, and excellent climate." He found it on Rancho Malibu, and from 1890 to 1891 he supposedly paid $300,000 ($7,185,374 now) to buy 13,300 acres of coastal ranchland and scenic beauty.

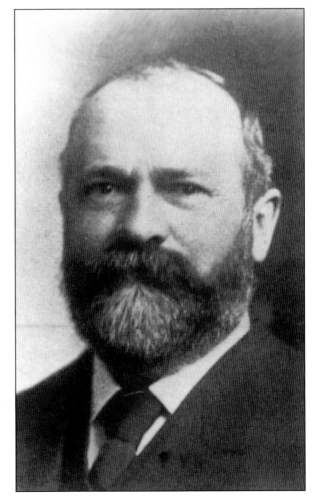

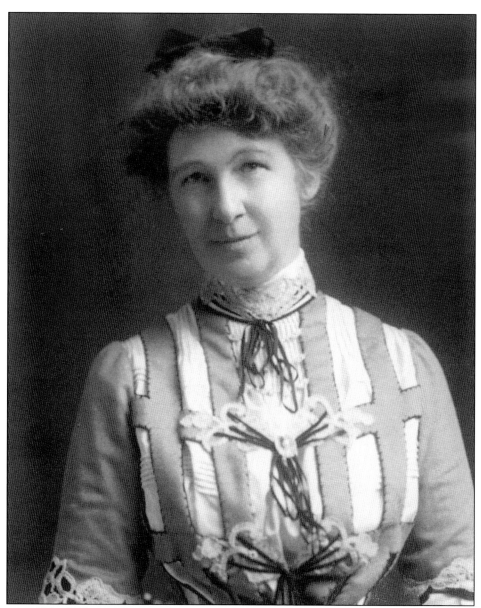

RHODA "MAY" KNIGHT RINDGE (1865–1941). May became a widowed millionaire when her husband, Frederick Rindge, died unexpectedly in 1905. Frederick came from a family of Puritan businessmen and had gone to Harvard. May Rindge was a former schoolteacher and mother of three who was not trained to take on an empire. She could have easily sold Rancho Malibu and divested herself of some of the $22 million in her husband's estate, allowing her to live like a queen in Paris or anywhere. Instead, she chose to stay on Rancho Malibu and carry through her husband's vision of carefully developing Malibu into the California Riviera. Starting in 1907, May began a long battle with homesteaders, hunters, fishermen, cattle rustlers, gangsters, thugs and smugglers, squatters, the Southern Pacific Railroad, the Counties of Los Angeles and Ventura, the Cities of Santa Monica and Venice, the State of California, and eventually Uncle Sam—all of whom wanted to infringe on Rancho Malibu with railroads, highways, and other plans. She wasn't going to win, but she wasn't going to quit.

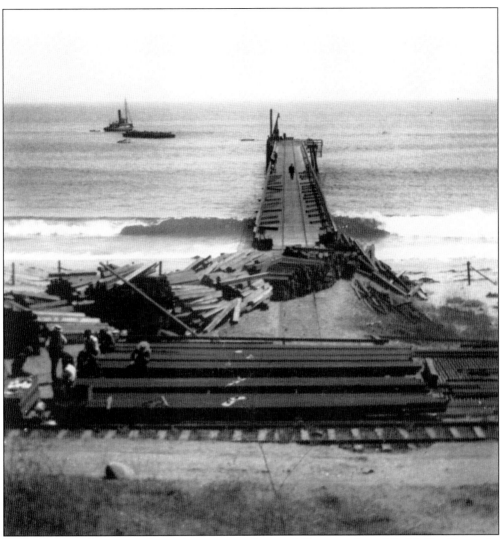

PIER '05. This photograph shows the structure that would become the public Malibu Pier under private construction. This was around 1905, the year Frederick Rindge died and May Rindge chose to continue her husband's vision to keep Rancho Malibu private. That vision included constructing a pier at the place still called Keller's Shelter. The pier was built to bring in railroad ties, tools, and equipment to build a railway that would service the sprawling cattle ranch. It was also built to block the ambitions of Southern Pacific Railroad. The Rindges invested $1 million (worth $20 million now) of their own money to build the Hueneme, Malibu, and Port Los Angeles Railway. The railway is long gone, but the service pier remains in an extended, improved public form. The Rindges used the pier to import equipment and export beef, leather, and other produce. As the Rindge estate thrived in the 1920s, they tied up their luxury yacht *Malibu* to the pier.

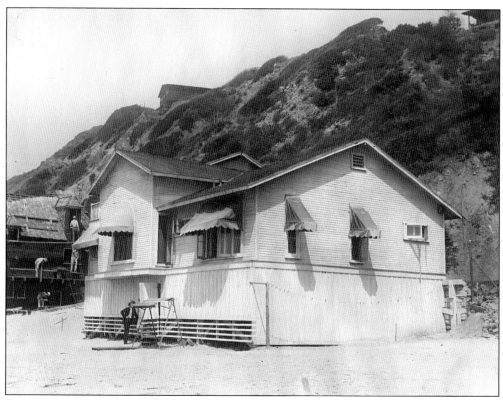

RADIO EVANGELISTA. Rancho Malibu was still private in 1914 when the mother of mass communications evangelists lived in this house on Las Tunas Beach about two miles east of Las Flores Canyon. Born in Canada in 1890, Aimee Semple Macpherson was pioneering the use of radio broadcasts to spread the gospel by 1914. Around the same time, she suffered a nervous breakdown. This photograph shows the beach house where she recovered.

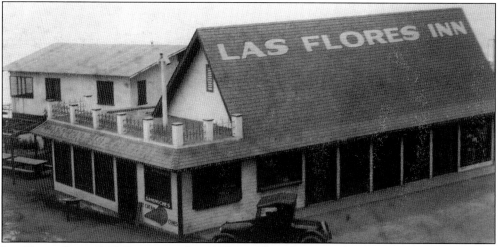

LAS FLORES INN, 1915. First opened in 1915, Las Flores Inn is credited as "Malibu's first eatery." Located at the bottom of Las Flores Canyon—the eastern border of Rancho Malibu then and where Duke's Malibu is now—this photograph, when pulled back, shows a fleet of flivvers sharing parking space with just as many horses. Cars and animals shared road space in the early 1900s.

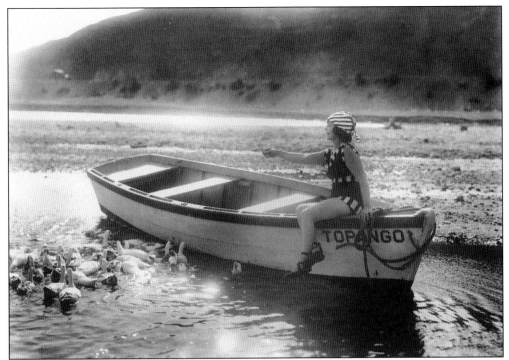

TOPANGO LAGOON, 1925. Topanga was spelled "Topango" through the early 20th century. The word comes from the Tongva tribe, neighbors to the Chumash, and means "a place above." At some point, the place name underwent a sex change to the feminine form. This photograph shows a bathing beauty feeding ducks from the good ship *Topango*, which is floating in a Topanga lagoon that was much larger (and cleaner) than its diminished size in the early 21st century.

ANY WOMAN, 1925. Another starlet goes into the briny waters. This time it is most likely Alice Terry, who starred in the 1925 silent film *Any Woman*. Those who know the nooks and crannies of Malibu believe that the point in the background is where the Chart House is now, so that would make this location roughly in front of the Getty Villa, where Coastline Drive meets Pacific Coast Highway.

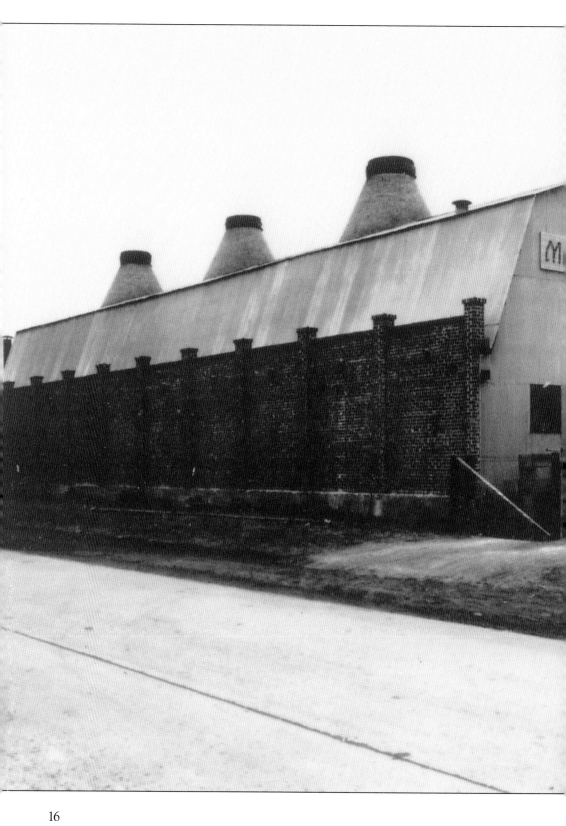

MALIBU POTTERIES, 1926. From the 1800s into the 1900s, attempts to mine gold and drill for oil on Rancho Malibu were fruitless. But the irony of all that digging and drilling is that the real mineral wealth was as common as clay. On June 13, 1926, the *Los Angeles Times* reported that May Rindge's first $250,000 of a million-dollar investment was paying off with "a long-cherished vision" as the first tiles came out of Malibu Potteries. "The first commercial orders of varicolored, glazed decorative tile are in the process of baking in the three great master kilns of the plant," the *Los Angeles Times* reported. In another *Times* article on June 27, Rindge invited "prominent Los Angeles architects, engineers, and builders to inspect the Malibu Potteries." She said, "It has always been my desire to utilize the natural nonmetallic minerals that occur in such large deposits on the property, before it would be opened for subdivision." The decorative tiles produced by Malibu Potteries were used in some of the most lavish houses built during the Roaring Twenties.

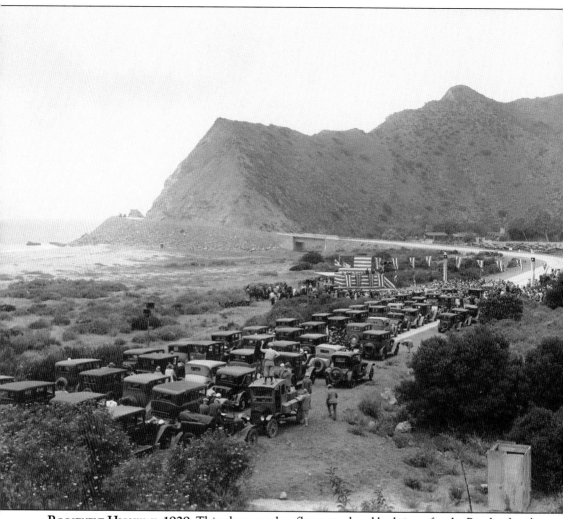

ROOSEVELT HIGHWAY, 1929. This photograph reflects good and bad times for the Rindge family. On Saturday, June 29, 1929, the *Los Angeles Times* wrote, "For the first time in more than a century, the general public was today given access to the scenic wonders of the famous Malibu Ranch when the last link in the Roosevelt Highway extending from Canada to Mexico was formally opened and dedicated by Governor Young at ceremonies in Sycamore Canyon near the Ventura–Los Angeles county line." A procession of 1,500 cars, escorted by the Goodyear airship *Volunteer*, convoyed from Los Angeles through Malibu Rancho to the ceremony held about five miles west of the western boundary at Arroyo Sequit. The Rindge family was not happy with the public driving through its private principality and was unwelcoming—even if it hair-lipped Governor Young. Starlets representing Canada and Mexico lit fireworks that exploded the gate, as this last bit of the Roosevelt Highway now linked those two nations by way of Malibu Rancho.

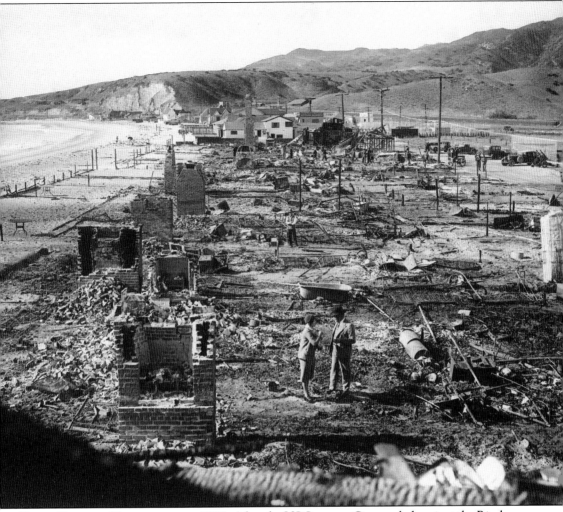

THERE GOES THE NEIGHBORHOOD, 1929. After the US Supreme Court ruled against the Rindge Company and for the Roosevelt Highway in 1923, development was inevitable. In 1927, Swedish film star Anna Q. Nilsson was the first to lease a lot at Malibu Colony and build a beach cottage. Within two years, dozens of movie people and others were paying $33 a month ($416.07 in modern dollars) to lease beachfront lots. James Cain, who wrote "The Widow's Mite" for *Vanity Fair* in 1933, described a fire that happened in the area, stating, "But then Mrs. O'Leary's cow got into it. The fire started from defective wiring at No. 83, what is now John Gilbert's house, on October 26, 1929." The fire destroyed 29 houses—and the stock market crashed two days later on Black Monday—but this was Malibu Colony. All were eager to rebuild even when the monthly lease was increased, from $33 a month for leases that would expire in 1936 to $75 a month for leases that would expire in 1941. Rebuilding began immediately.

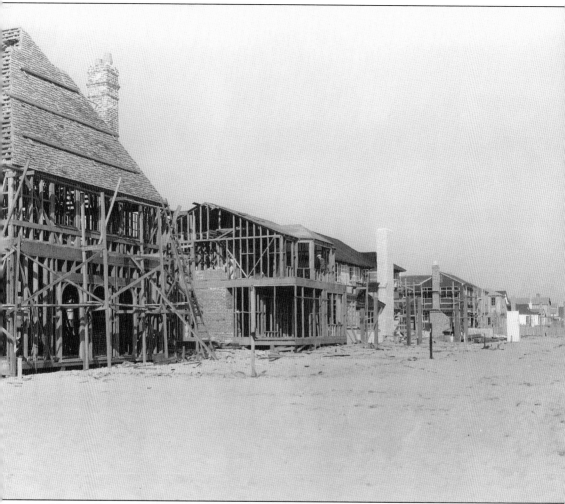

MALIBU COLONY REBUILDS, 1930. The caption on the back of this 1930 Nancy Smith publicity photograph reads: "Here's a view of the section of Malibu that was swept by the fire last season. See how the star-owners hopped into action after the fire. Most of these homes are now completed and the stars are living in them."

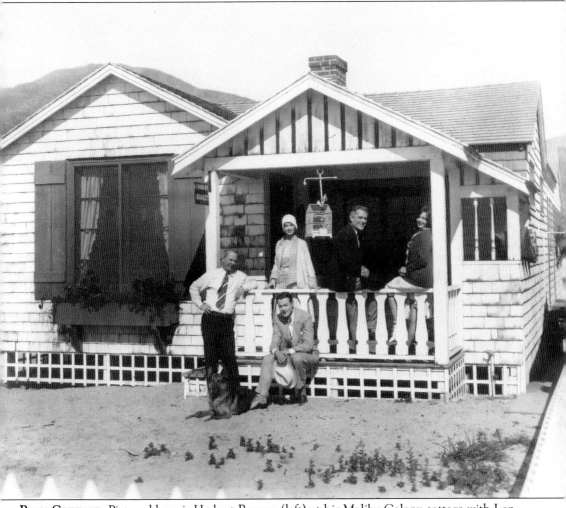

Beau Cottage. Pictured here is Herbert Brenon (left) at his Malibu Colony cottage with Lon Chaney (on porch, center). Brenon directed *Beau Geste* in 1927, and with a close look the sign reads, "Beau Geste." From "The Lon Chaney" website (lonchaney.org), Loretta Young remembered when Herbert Brenon "was in a sanitarium . . . [and had] a nervous breakdown . . . between the time he made *Peter Pan* (1924) and *Laugh, Clown, Laugh* (1928). Anna Q. Nilson lived on the beach . . . a couple of doors down from Herbert Brenon."

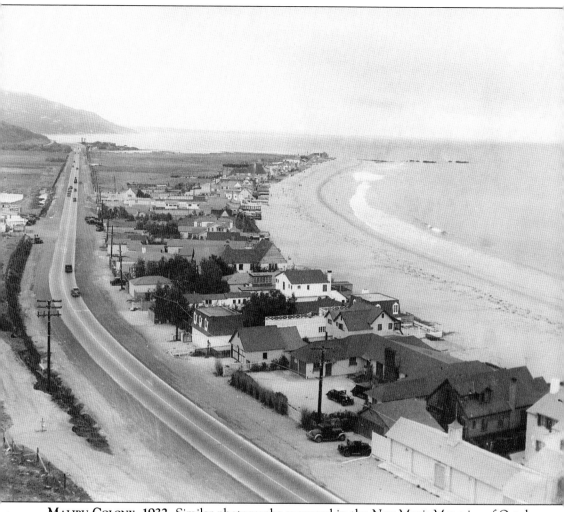

MALIBU COLONY, 1932. Similar photographs appeared in the *New Movie Magazine* of October 1932 in a story called "Tom Mix Exposes Malibu Beach." The article describes the area, "It's a bleak spot, about 25 miles up the coast from the Hollywood studios, where the more prosperous ones of the industry and others, too new . . . to know what it is all about, have built themselves homes on rented property. . . . Malibu is a thrivin' community of about 1200 souls and 600 actors. A recent census, taken by three local finance an' mortgage companies, shows an average of one an' a half dogs an' two an' six-tenths servants to each paid admission or inhabitant. . . . A few weeks ago, Mrs. May Rınge [sic], who owns the 20,000-acre Malıbu ranch, decided to let the Malibu beachers buy the lots outright—and one of the first to plank down real cash was Jack Warner, [who] paid $36,000." The amount that Warner paid in 1932 is now worth $569,071.21.

CRAWBANKS/FAIRFORDS. The glamorous "Brangelina" couple of the 1930s was Joan Crawford and Douglas Fairbanks Jr. Crawford was born as Lucille Fay Le Sueur in San Antonio in 1905. Douglas Elton Ulman Fairbanks Jr. was born in 1909 in New York City. Le Sueur came from a broken home but had singing and dancing talent that whisked her to Hollywood in 1925. Fairbanks came from wealth and Hollywood royalty and began to make a name for himself as an actor in 1925 with the roll of Richard Grosvenor alongside Malibu Colony resident Ronald Colman in the film *Stella Dallas*. Le Sueur/Crawford began taking small parts in 1925, and she became a star in 1928 with *Our Dancing Daughters*. Crawford and Fairbanks Jr. were married in 1929 and became the Pitt-and-Jolie Hollywood star couple of the time. They were often photographed cavorting on the beach at Malibu, playing baseball, swimming, and looking like movie stars. They both survived the transition from silent movies to talkies in 1929, but their marriage ended in 1933.

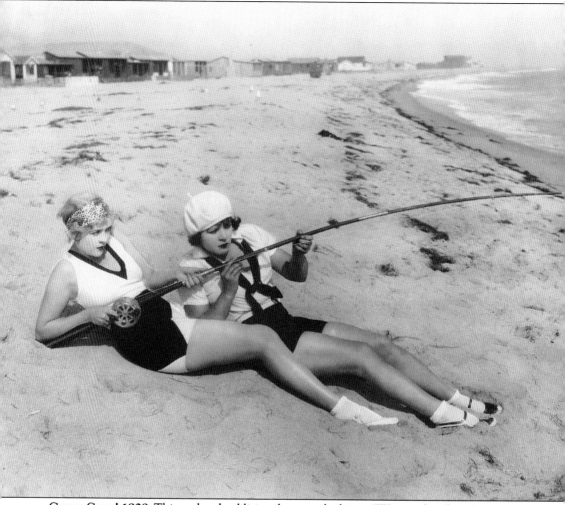

GREAT GAMS! 1929. This undated publicity photograph claims, "Waiting for a bite! Marie Prevost and Phyllis Haver seem patient enough, but then again, it looks like they are beginning to tire while awaiting the decision of a finny beauty to attack the bait. Miss Prevost and Miss Haver spend many an enjoyable week-end between their work in Pathe-Demille pictures at Miss Prevost's beach cottage." Haver (left) did hook a millionaire, marrying New Yorker William Seeman in 1929. She told Cecil B. DeMille she was ending her contract with him under the "Act of God" clause, saying, "If marrying a millionaire isn't an 'Act of God,' I don't know what is!" Prevost (right) did not make the transition from silent films to talkies and also had weight problems. She was found dead of acute alcoholism and malnutrition in 1937. Haver stayed married to the millionaire until 1945 and lived until 1960.

Two

THE SWINGIN' THIRTIES
1930–1939

BLACK MONDAY. On a Monday in October 1929, the Dow Jones Industrial Average dropped by 12.8 percent in one day, inspiring an avalanche of selling and starting off the Great Depression. In Hollywood, 1929 was the transitional year from silent pictures to talkies, and silent film actors and actresses found their careers teetering on the brink of how they sounded and not just how they looked. Around Malibu, 1929 was the year the Roosevelt Highway opened, literally paving the way for the development of Malibu Rancho. Into the 1930s, Malibu Colony grew rapidly as movie stars and new money moved in while some of the silent stars moved out. Malibu Colony was a principality of prosperity on the edge of a country that was suffering high and low. Malibu Colony resident Hugh "Woo Woo" Herbert shows off his cross-training skills and the shtick that led to a career as a 1930s comedy actor. His zany persona was punctuated by cries of "woo woo!" and "oh, wunnerful, wunnerful."

OCEANFRONT PROPERTY. A couple of suits chat on the beach—maybe doing movie deals, maybe talking Malibu Colony leases. In 1932, Tom Mix wrote about the business of Malibu Colony, "The original Malibu leases were such that no one, except a bunch of newly rich motion actors, would ever have signed them in the first place. The pioneer residents did not buy the property; they bought leases, payin' $30 per month per lot. At the end of 10 years, the property an' all improvements reverted back to the original owner, the Malibu Ranch. An' upon these terms, the thrifty picture folks rushed in an' built homes costin' $5,000, $10,000, an' even $15,000 on leased lots. Jack Warner erected one that that cost $60,000—generally known as 'Warner's Folly'—an' although he has had it almost two years, the Warners have spent less than two weeks in the place."

TRANCAS LIGHTHOUSE, 1929. Stage actress Pauline Frederick made the transition to film in 1915 and became one of the most important actresses of the 1920s and 1930s. According to the website "Pauline Frederick, Tragedienne of the Silent Screen," put up by Greta de Groat, "In 1920, Goldwyn opened a West Coast studio, and the newly divorced Frederick and her mother moved to California. A few years later she bought a beach house in Malibu as well. . . . This home was at 23544 Roosevelt Highway, Malibu. . . . The road has since been renamed Pacific Coast Highway, but it must have been renumbered as well, since that address does not correspond with the location at Broad Beach near Trancas Canyon. The house was built in the shape of a lighthouse, [and] next door businessman Freeman Ford built a home in the shape of a boat. Both were local landmarks for years."

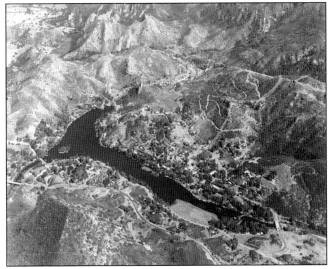

MALIBOU LAKE. This aerial photograph of Malibou Lake was taken in 1949. This book is about Malibu, and Malibu is all about Hollywood, and a lot of Hollywood movies were shot at Malibou Lake; thus an establishing shot is required. "Malibou" is not a typo or the result of Depression-era illiteracy. Some say the odd spelling stays closest to the original Chumash spelling of Humaliwo, while others say it was to avoid legal troubles with the litigious May Rindge.

LAKE VIEWS. In the 1920s, Bertram Lackey and George Wilson's plans to develop 350 acres of land included a 44-foot-high dam to create a 65-acre lake. Over the next four years, they constructed a clubhouse with 24 bedrooms, a lounge, dining room, stage, locker rooms, barbecue pit, baseball diamond, rowboats, and swimming facilities. Rains in 1926 finally formed a lake as club members and investors celebrated with a rain dance.

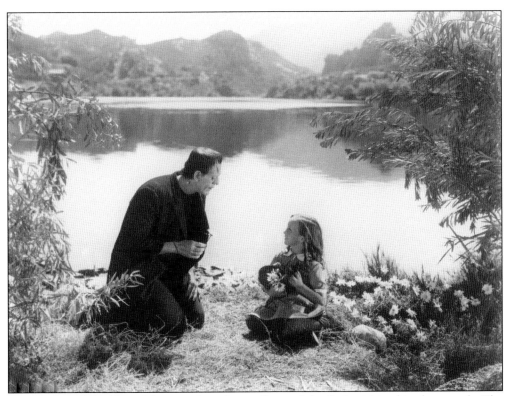

MONSTROUS. "Would you like one of my flowers?" stated the little girl in this photograph. The artificial Malibou Lake became a very popular spot for shooting movies requiring a lake backdrop that could have been anywhere, like Lake Geneva. This is a scene from the 1931 film *Frankenstein*, based on Mary Shelley's 1817 novel. Of all the scenes and movies shot on and around Malibou Lake, this could be the most famous.

COLBERT/BOYER. Claudette Colbert and Charles Boyer made three movies together: *The Man from Yesterday* (1932), which takes place in Switzerland, *Private Worlds* (1935), where the set is in a mental hospital, and *Tovarich* (1937), which is about a royal Russian couple living in poverty in Paris. This could be a location shot from any of those movies, as Malibou Lake in 1932 could be made to look like anywhere. Chances are, though, that this is from *The Man from Yesterday*.

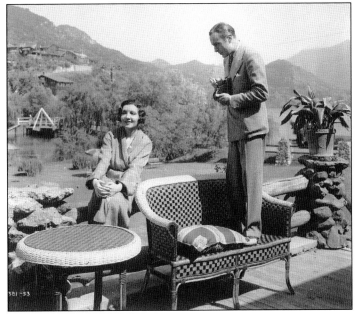

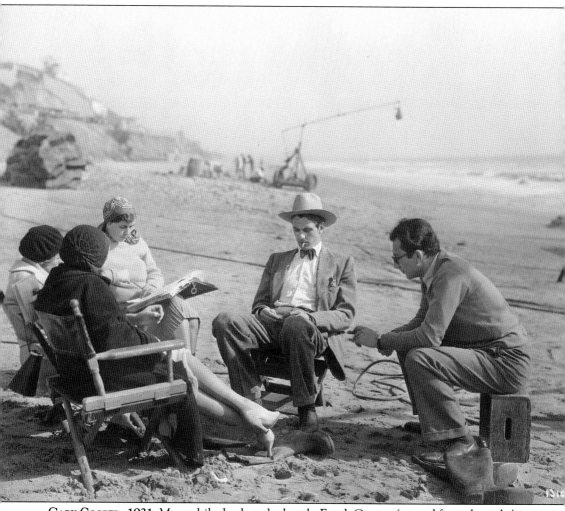

GARY COOPER, 1931. Meanwhile, back at the beach, Frank Cooper (second from the right) is on a movie set. Cooper was born on a ranch in Montana in 1901 but found nothing romantic about shoveling manure in minus-40-degree weather. Frank went west to grow with the movie business in the middle 1920s. He took the stage name Gary Cooper and was paid $20 a day for bit parts in 1925, but by 1931 he was a rising star and owned an Encino ranch where he grew corn and avocados. This image shows Cooper and director Rouben Mamoulian on the beach in Malibu in 1931 for the gangster picture *City Streets*. Cooper plays a shooting gallery showman who resists becoming a gangster until his girlfriend is sent to prison for murder. What did any of that have to do with the beach? You'll have to watch the movie.

RONALD COLMAN. A character in *A River Runs Through It* (1992), which is set in Montana in 1937, talks about jumping a train to California to ride waves with Ronald Colman, who was one of the first people to build a beach bungalow at Malibu Colony; his house was No. 16. Colman was a keen surfer, hanging out with Hawaiian Olympian Duke Kahanamoku and even with people from as far away as Montana who wanted to surf—like Gary Cooper, who was also a surfer.

LOUISE FAZENDA. In 1930, Louise Fazenda had more than 100 shorts and features to her credit, had married Warner Brothers' producer Hal B. Wallis, and was a major movie star with a featured role in *No, No, Nanette*. That lifestyle afforded her a two-story home in the Malibu Colony, with an aquaplane at the ready for cruising around the ocean or maybe Malibu Lagoon while being towed by a boat.

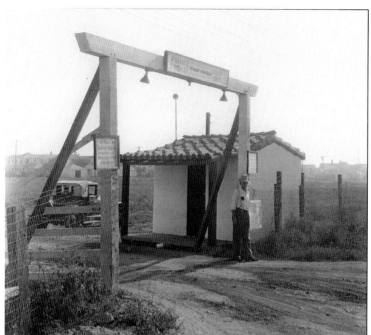

MALIBU COLONY GATE, C. 1934. According to Evelyn Brent in the book *The Life and Films of Hollywood's Lady Crook* by Lynn Kear and James King, "In order to keep their sanctuary private, a gateman was hired to keep out stray cars and tourists. 'Seven patrolmen are on duty night and day. Protecting the homes from gate crashers that may have gotten past the gateman, souvenir seekers, over-eager fans, and yes, gangsters.' "

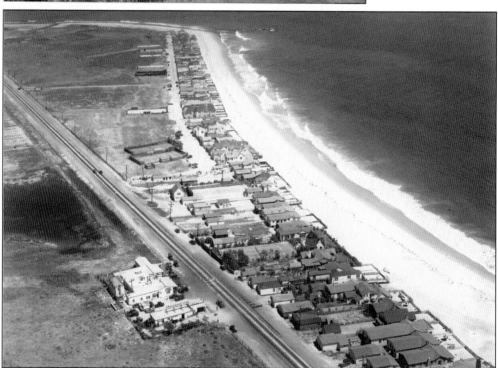

MALIBU COLONY, 1932. If the 1932 date on this aerial is accurate, then only five years after Anna Q. Nilsson's first lease and three years after the fire, the colony was booming. Writing for *Vanity Fair* in 1933, James M Cain explained, "So I shall merely note that at $400 a foot [$6,324 now], a 30-foot lot costs $12,000; that $12,000 [$189,720 now] is almost exactly the amount required to cover such a lot with $1 bills."

Bow Cottage. The Marilyn/Madonna of her time, Clara Bow roared with the Twenties. Born in New York in 1905, she first appeared in *Beyond the Rainbow* in 1922 and rose quickly as the flapper sex symbol of the 1920s. She appeared in Howard Hughes's *Wings* in 1927 and also the movie *It*, which got her crowned as the "It Girl." By the end of the decade, she was the top box-office draw, and she was making $35,000 a week ($441,000 today), as she was almost a guarantee of a 2-to-1 return on investment. Her thick Brooklyn accent did not survive the transition to talkies, and her "bad girl" reputation did not jibe with the Depression years. This photograph of her Malibu Colony cottage was taken in 1933, the year she made her last movie before she moved to Nevada with her husband, Rex Bell, an actor who became lieutenant governor of Nevada.

LILYAN TASHMAN. Known for her roles in *No, No, Nanette* (1930), *Puttin' on the Ritz* (1930), and *Frankie and Johnny* (1934), the caption on this publicity photograph reads, "A BEACH BUILDER—Lilyan Tashman, Paramount player, supervises the construction of a new home at Malibu Beach, California. The interior of the residence is to be decorated and furnished entirely in white and red, an innovation created by Miss Tashman."

LILYAN AND JACK. This publicity photograph suggests Tashman's finished cottage kept the original color scheme, and its caption reads, "ANOTHER BEACH COMBER—Paramount Player Lilyan Tashman uses the Pacific ocean for the front yard of her new beach home at Malibu, a residence completed entirely in red and white. Even Miss Tashman's bathing suit matches the symphony of color—the trunks being of red and white stripes. The dog is Jack."

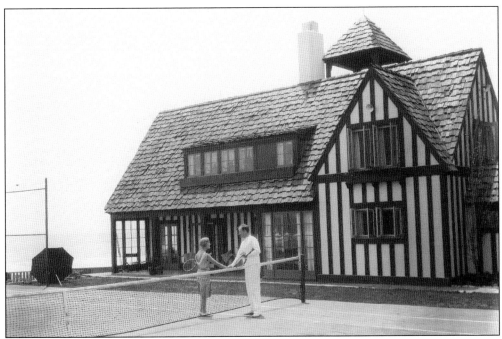

LA PLANTE AND SEITER. The undated caption on the photograph above reads, "AND THEY CALL THIS A COTTAGE!—The new beach home of Laura La Plante, Universal star, at the Malibu near Los Angeles. Laura and friend husband [sic], William Seiter, director, are about to engage in a tennis game on their private court." Laura La Plante (also seen below) started as a bathing beauty and became a star during the 1920s. In 1926, she married director William Seiter, who was known for making comedies with the likes of the Ritz brothers, the Marx brothers, Shirley Temple, Laurel and Hardy, Abbott and Costello, and W.C. Fields. In the 1926 comedy *Skinner's Dress Suit*, La Plante was directed by Seiter, which was the year they were married. She did not make a smooth transition to talkies and neither did her marriage, as she divorced Seiter in 1934.

SYLVIA SIDNEY. Writing about Malibu Colony in a 1933 article for *Vanity Fair*, James Cain talked about the Depression-era version of the beautiful people: "Yet you can't say that it is not beautiful, any more than you can say that certain other creations of God, here, visible pretty much as God made them, are not beautiful. Isn't Sylvia Sidney beautiful?"

SYLVIA'S SEAWALL. Sylvia Sidney looks beautiful posing for a publicity photograph on the sand wall of her home along the west end of the colony—the location can be determined by the cliffs in the background.

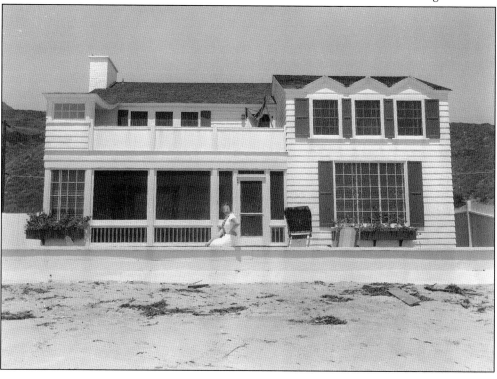

SHE IS SO WARM RIGHT NOW. The caption on this 1934 photograph reads, "A FIRESIDE GAL—Sylvia Sidney, Paramount player, spends the cool summer evenings by this picturesque hearth in her now early-American beach cottage. The entire room is carried out in original antiques of the colonial and early-American period."

BEETLEJUICE JUNO. Sylvia Sidney's long career spanned *Thru Different Eyes* in 1929 to *The Love Boat* in 1998 with 100 roles in between, including *Sabotage* in 1936 with Alfred Hitchcock. If she looks familiar, she was the 78-year-old actress who played Juno, the desk-bound, afterlife bureaucrat advising and chastising the recently departed Alec Baldwin and Geena Davis in *Beetlejuice* (1988).

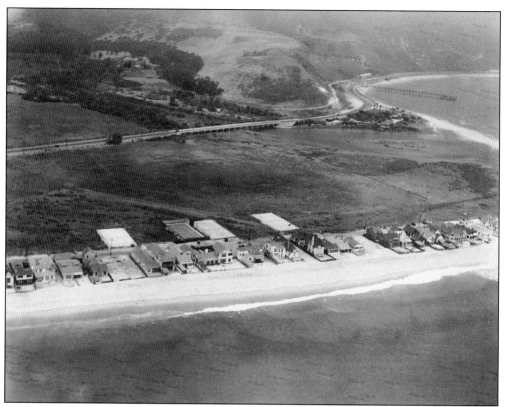

COLONY, 1935. This aerial photograph shows most of Malibu Colony looking northeast toward Malibu Creek, the lagoon, and the Malibu Pier, which opened to the public in 1934. The white building beyond the pier is the train shed the Rindges used to store the engines and equipment for the Hueneme, Malibu, and Port Los Angeles Railway.

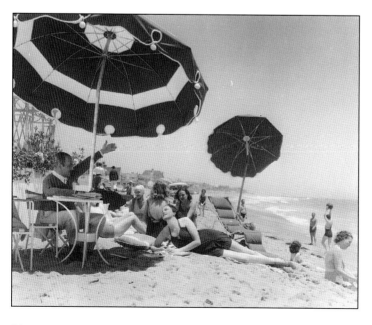

HOLLYWOOD BOULEVARD, 1936. This photograph is a behind-the-scenes look or an actual scene from *Hollywood Boulevard*. As a favor to the director, Gary Cooper made a cameo in this exposé of scandal and gossip magazines of the 1930s.

CLAIRE TREVOR. At the 70th annual Academy Awards in 1998, Michael Caine called Claire Trevor "a living legend." Trevor is seen here in 1935 kicking it on the beach along Malibu Colony. During a career that started in 1933 and ended in 1978, she won an Oscar in 1948 for *Key Largo*, starring alongside Humphrey Bogart and Edward G. Robinson.

WOOL ON THE BEACH. These swells are wearing wool tank suits on the Malibu Colony beach. Before 1936, it was improper and illegal for men to bare their chests in public. Hollywood changed that when Johnny Weissmuller wore a loincloth in *Tarzan the Ape Man* (1932). His role as Tarzan began to break the ice of what men could wear on the beach in public—not loincloths, of course, but no more wool tank suits.

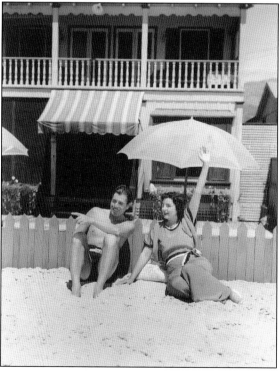

WARNER BAXTER 1933. The caption on the back of this photograph reads, "Warner Baxter, Fox Films star, is one of the 'first settlers' of Malibu Beach, where he has lived for the past six years during the summer months. This is his 'back yard' fronting on the Pacific. It is a colorful spot with its gay orange and green accessories." Doing the math, this photograph dates to 1933.

WARNER AND WIFE. Warner Baxter began making movies in 1914 and won the 1928 Oscar for Best Actor for his role as the Cisco Kid in *Old Arizona*. Baxter also starred with Myrna Loy in *Penthouse* (1933) and portrayed Dr. Samuel Mudd, the man who paid dearly for patching up Lincoln assassin John Wilkes Booth in *The Prisoner of Shark Island* (1936). Sitting next to Baxer in this shot is his wife, Winifred Bryson Baxter, who looks a bit like Roseanne Barr.

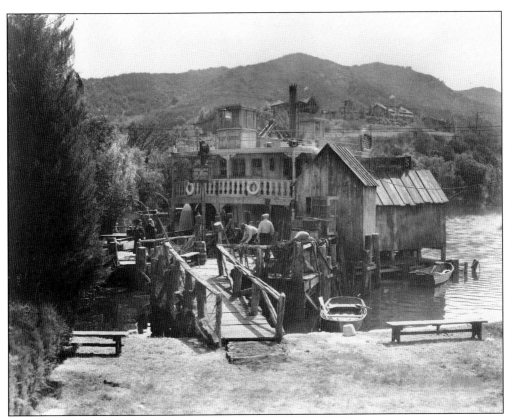

W.C. FIELDS, 1933. Brian Rooney is the author of *Three Magical Miles*, a detailed local history of moviemaking at Malibou Lake, Century Lake, the Fox Ranch, and the surrounding area. Rooney believes this is a set and scene from the 1933 movie *Tillie and Gus*, starring W.C. Fields.

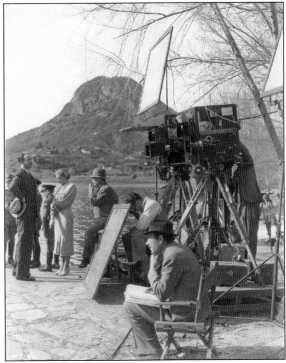

FRANCES AND ALFALFA. At Malibou Lake, the cameras were rolling nonstop as the talkies took over the 1930s. *Too Many Parents* (1934) included Frances Farmer in her debut role with Carl 'Alfalfa' Switzer in a cameo and guitarist Cal Tjader. Director Robert McGowan (to the right of Farmer) was known for shooting many of the Our Gang/Little Rascals series of films for Hal Roach Studios.

TWO GIRLS FOR EVERY SIR GUY.
A British citizen, Guy Standing
was a commander in the British
Royal Navy during World War
I. In Hollywood, Sir Guy was
best known for his role as Col.
Tom Stone in *Lives of a Bengal
Lancer* (1935). The two starlets
are Frances Drake (right) and
Grace Bradley. Sir Guy died of
a rattlesnake bite while hiking
in the Hollywood Hills in 1937.

TWO GIRLS FOR EVERY BOAT.
The caption on this 1936
Paramount publicity photograph
reads, "YOUTHFUL DUO—when
they are not busy in Paramount
productions, Jane Rhodes, seated,
and Olympe Bradna, young
featured players find relaxation
in boating. You'll be seeing Jane
soon in *The Arizona Raiders* while
Olympe is a featured dancer in
Paramount's *Three Cheers for Love*."

42

CASTING CALL. According to a long, complicated synopsis on the "Internet Movie Database" (IMDB) website, this is one of the plot points for *She Asked For It* (1937): "After 15 novels, Dwight refuses to write another line, defies his wife and his agent, and goes on a fishing trip." This must be the fishing-trip scene, and logically this must be William Gargan as Dwight Stanford.

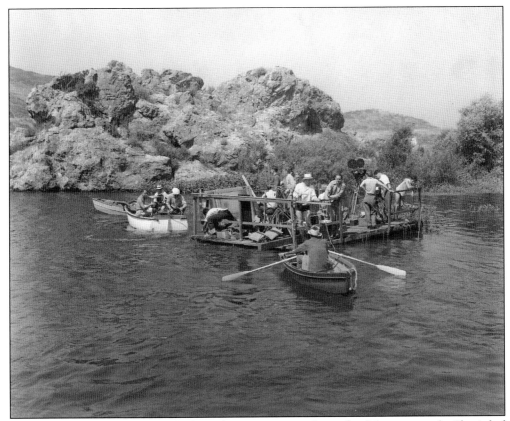

RAFT SERVICES. The floating platform they are using to shoot the fishing scene for *She Asked For It* would probably not pass current Occupational Safety and Health Administration (OSHA) standards and would most likely get the production shut down—but in 1937, they made do.

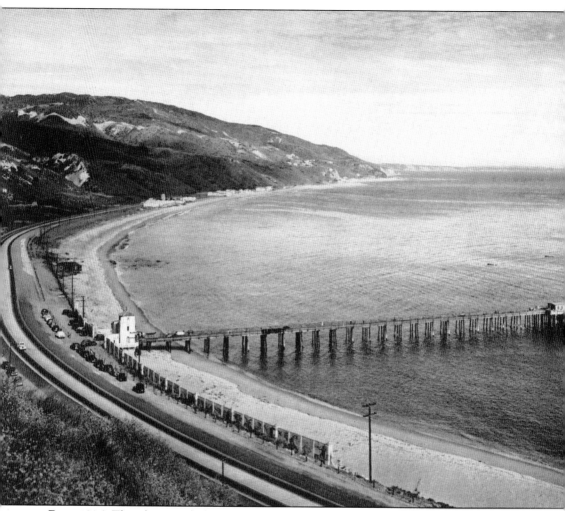

PIER, 1936. This photograph shows Malibu Pier in 1936, seven years after the Roosevelt Highway opened traffic through the Malibu and two years after the pier opened to the public. On July 6, 1934, the *Los Angeles Times* ran headlines, "Big Barracuda School Hits Southland Waters" and "Malibu Pier Opened to Public for First Time," and reported, "A run of exceptionally big barracuda is giving saltwater anglers a run for their tackle this week. . . . The Malibu Pier, located about 12 miles north of Santa Monica was opened on July 1, a barge being anchored a short distance away and two live-bait boats leaving the pier on a daily schedule, one boat making half-day trips. . . . A small fee is assessed anglers who wish to fish from the pier." The big runs of barracuda are long gone, which is a good thing for modern surfers. This was the Depression, and people were not fishing for fun, they were fishing for food.

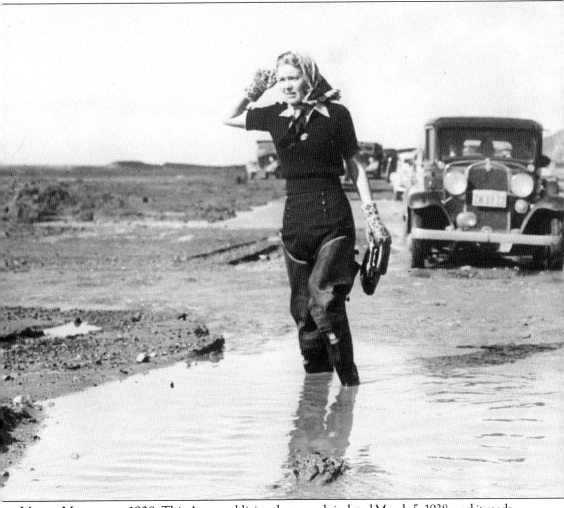

MUDDY MADELEINE, 1938. This Acme publicity photograph is dated March 5, 1938, and it reads, "FLOODS MAKE ACTRESS CARROLL REAL ADVENTURESS—Film player Madeleine Carroll found herself up to her knees in adventure after three days and three nights marooned in her Malibu Beach home 35 miles from the Walter Wanger Studio. Miss Carroll, star of *The Adventuress*, finally reached a studio rescue party after a four-mile hike along the beach, muddied and torn by the March flood waters." In 1938, a 50-year storm dumped more than nine inches of rain from February 27 to March 1, killing as many as 115 people and causing $40 million ($627 million in 2011) in damage and destroying over 5,000 buildings. The storm also inconvenienced at least one blonde bombshell. Carroll was the first of Hitchcock's blonde ingénues in *The 39 Steps* (1935). During World War II, her sister was killed in a bombing raid on London, and she put aside her acting career for three years to work in field hospitals, earning a Legion d'Honneur for bravery in France.

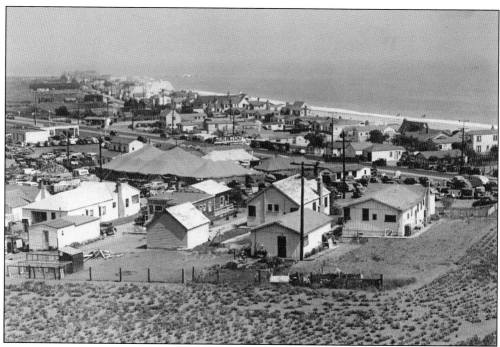

DOG DAYS OF SUMMER. On August 13, 1939, the *Los Angeles Times* ran an article headlined, "Judging Begins on Malibu Dogs: Movie Colony Show Includes 500 Animals; Exhibit Closes Today," and reported, "Dogdom from nervous Chihuahuas and perky Pomeranians to mighty Mastiffs and haughty Bouviers des Flanders, favorites of the Movie Colony and the public, were on parade and in competition yesterday at the all-breed show of Malibu Kennel." The next day, the *Los Angeles Times* announced that a Great Dane had been judged Best of Show.

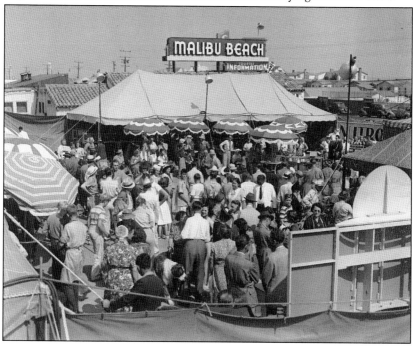

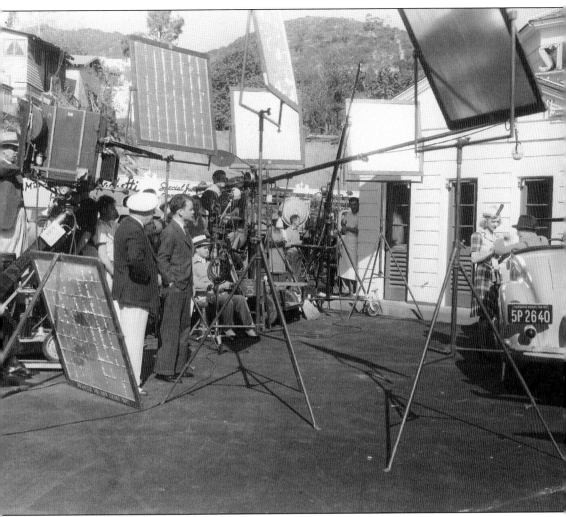

SIMON'S SET. Simon's Drive Inn rose in 1935 as the "West's largest restaurant chain" with two dozen locations from Los Angeles to Beverly Hills to Pasadena. Local movie history expert Mike Malone looked through the Fox files and found that the movie code "407" stood for *The Jones Family in Hollywood* (1939)—the Griswolds of the 1930s.

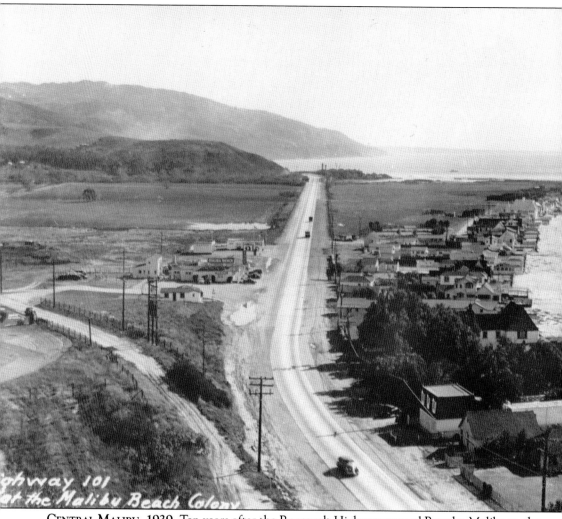

ghway 101
at the Malibu Beach Colony

CENTRAL MALIBU, 1939. Ten years after the Roosevelt Highway opened Rancho Malibu to the public, what had been private open fields, cattle paddocks, wetlands, and lone prairies was gradually being civilized and transformed. Malibu Colony thrived during the 1930s, as the movie business thrived because people who could barely afford a car or food could still come up with the money to go to the movies—films provided an escape from a dreary decade. This is the Malibu Colony as it looked in 1939. The economic future is looking brighter, but war was around the corner, and that would change the world, the movie business, Southern California, and Malibu forever.

Three

LIFE DURING WARTIME AND AFTER

1940–1949

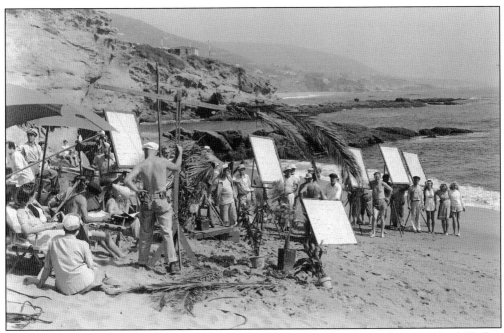

WAR COMES TO MALIBU. Reading the *Los Angeles Times* in the 1940s, the post–Pearl Harbor fear of the "Japs" was similar to the post–September 11 mistrust of Muslims. The *Los Angeles Times* for March 4, 1942, printed the headline, "Map Reveals Jap Menace," and printed a detailed map of California land owned by Japanese, reporting, "Typical is almost a square mile leased by Kiichi J. Takahashi on the flat beach midway between Point Dume and Topanga Canyon." The Adamson House and the Malibu Pier became part of the coastal defenses when night blackouts were mandatory, and that included driving at night on the coastal highway. In April 1942, three kids fishing on a sunken barge a half-mile off Malibu Pier were strafed by a flight of warplanes using the barge to tune their .50-caliber machine guns. The kids survived, but their rowboat did not. Life during wartime was dangerous around Malibu, but also busy, as Hollywood shifted gears to keep the world informed and entertained. This Paramount publicity photograph shows an unidentified 1941 war movie importing palm trees and other tropical props to the beaches of Malibu.

GEORGE RAFT. In 1940, the episode "Malibu Beach Party" in the Merrie Melodies theatrical cartoon series featured caricatures of Jack Benny and Rochester hosting parodies of a dozen Hollywood celebrities, including Fred Astaire, John Barrymore, James Cagney, Bette Davis, Alice Faye, Clark Gable, Greta Garbo, Bob Hope, Kay Kyser, Edward G. Robinson, Ginger Rogers, Cesar Romero, Mickey Rooney, Ned Sparks, Spencer Tracy, and this guy, George Raft. Born in Hell's Kitchen, New York City, in 1901, Raft began a career in movies in 1929 and made a name for himself in *Scarface* in 1932. Raft often played gangsters and tough guys, an image supported by reality, as he carried the aura of Mafia connections. He was friends with Bugsy Siegel and was banned from England in 1966 because of his reputation. A slick customer, he made statements such as this: "I must have gone through $10 million during my career. Part of the loot went for gambling, part for horses, and part for women. The rest I spent foolishly."

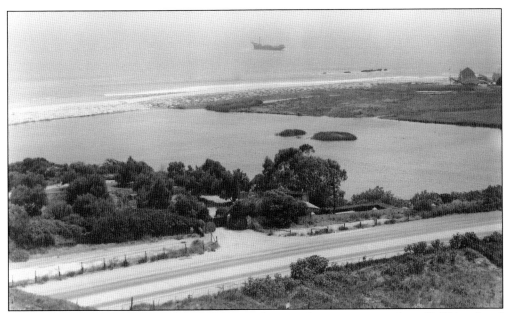

ACROSS CREEK. This Fox Location Department photograph series incorrectly spells "Ringe" and looks southwest from what is now Serra Retreat. In the image above, to the left is the Adamson House, 11 years after it was built. Looking over Roosevelt Highway and across Malibu Creek and Malibu Lagoon, the ship was a fishing platform called the *Virginia*. The configuration of the lagoon and wetlands as seen in 1941 was used by both sides of a 2011 battle over the "restoration and enhancement" of Malibu Lagoon. This was nature's original design, carved out over millennia, and some argued that the State of California should return the lagoon to its natural state. Former mayor Jefferson "Zuma Jay" Wagner also pointed out the remains of the Rindge railroad visible under the bridge in the photograph below. Leftover rails were used in the construction of Rindge Dam.

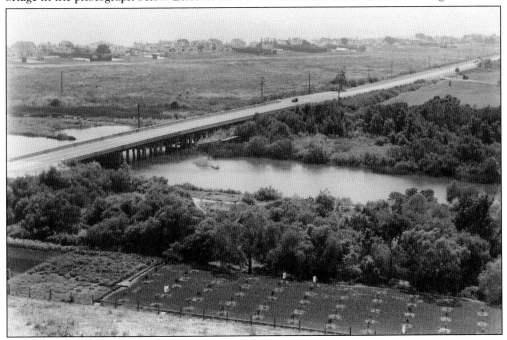

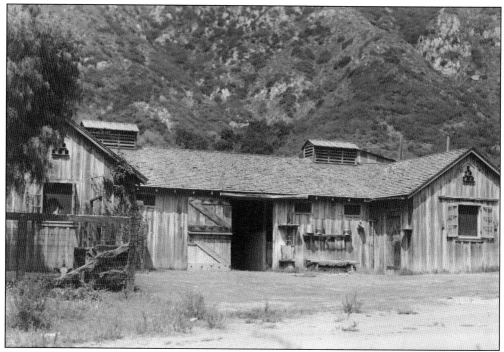

BETTER HOMES AND BARNS. In 1941, this barn belonged to the Rindge and Adamson families on what was then the Rindge Ranch but was about to become Serra Retreat, which was a gated community of luxury homes for the rich and famous. This barn is still there in a reconstructed, modern incarnation that stays true to the original. The Adamsons keep a team of mini-horses there, and it is not uncommon to see those horses today pulling carts through Cross Creek.

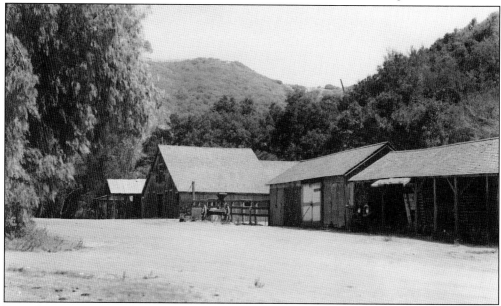

PALM CANYON DRIVE. This image looks along what is now Palm Canyon Drive in Serra Retreat. These barns and stables are no longer standing, but at the time the Rindges used the barn to store tiles from Malibu Potteries. Pieces of colored tile can still be found in the area.

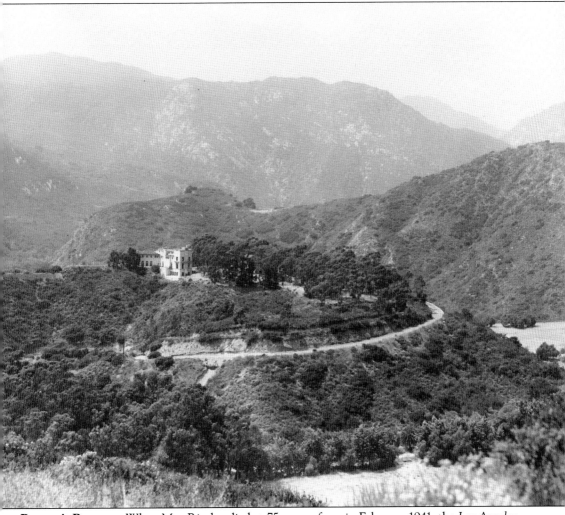

RINDGE'S RETREAT. When May Rindge died at 75 years of age in February 1941, the *Los Angeles Times* sent a reporter and photographer to witness what had been off-limits, like the 50-room palace that cost $500,000 (today $7,321,259). The *Los Angeles Times* reported that it was still "at least $100,000 short of the sum needed for completion of the castle." In all of those rooms were tile from Malibu Potteries. There was a huge laundry room, a vast music room, a huge baronial hall, a salad-mixing room, which was "four times the size of the average housewives' special domain," and even a suite "built for a son, Fred Jr., the bathroom is big enough to—and does—contain a swimming pool 3 by 17 feet." All of it was now for sale—the massive house and 130 acres around it. The *Los Angeles Times* wrote a sad postmortem, "But the dreams of the Queen of the Malibu are blasted now; her American Riviera can never exist in a land whose burgeoning population's needs and interests take precedence over those of the individual, no matter how rich or influential that person may be."

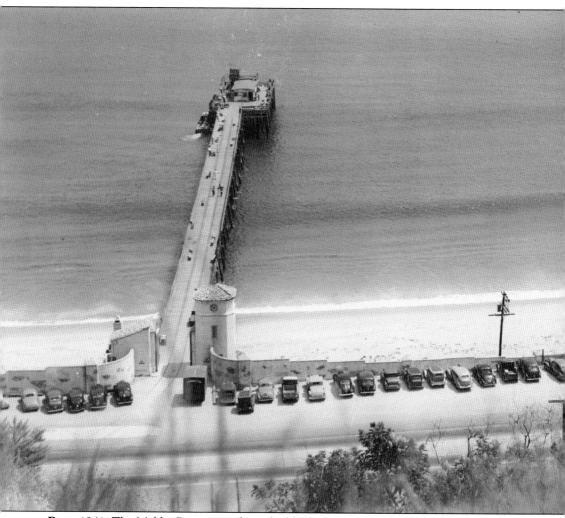

PIER, 1941. The Malibu Pier is seen from the bluffs above with a bit of swell showing from that long-ago Fox Location Department scouting mission on August 5, 1941. According to a history of the Malibu Pier posted online by the California State Parks Department, it was said that "after the bankruptcy of Marblehead Land Company (the Rindge's land operation) in 1936, the Malibu Pier was taken over by bondholders who had helped finance Malibu development. The pier was extended to its current 780-foot length, and the first small bait and tackle shop building was constructed at the ocean end by 1938. During World War II, the end of the pier served as a US Coast Guard daylight lookout station until an intense storm in the winter of 1943–1944."

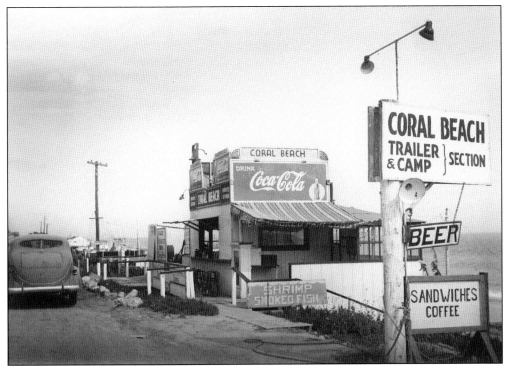

ROADSIDE ATTRACTION. These days, Corral Beach runs a mile from Malibu Road to Latigo Shore Drive. Malibu Seafoods is a popular restaurant on the inland side of Pacific Coast Highway, and just after that is the Malibu Beach RV Park. In 1941, the fish sandwiches and the camping were all together on the ocean side of the highway on Coral Beach. The second r in Corral Beach was added to the name later.

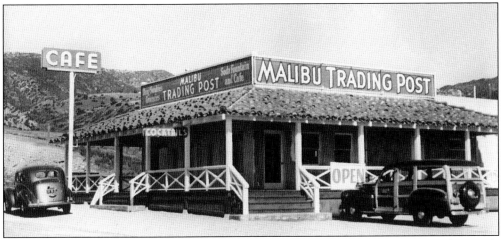

WEST MALIBU. Ten miles west of the Malibu Pier, Trancas was considered the sticks by the people of Malibu when Malibu itself was considered hopelessly rural by most of civilized Los Angeles. Malibu Trading Post had the only phone north of Malibu. Many traffic accidents were reported from that phone as the next civilization was in Ventura County, another 15 miles west.

BETWEEN US GIRLS (1942). "Diana Barrymore and Robert Cummings indulge in a bit of acquatic [sic] clowning while on location at Lake Malibu [sic] for scenes in Henry Koster's *Between Us Girls* production for Universal." The daughter of John Barrymore, Diane's chaotic life ended at 38 years old and was dramatized in *Too Much, Too Soon* (1958). Bob Cummings appeared 21 years later as the bearded anthropologist Professor Sutwell in *Beach Party*.

MORE H2O-JINX. It must have been hot around Malibou Lake during the shooting of *Between Us Girls*. The caption of this photograph reads, "How to dunk a director is illustrated by Robert Cummings, seen here trying to push Henry Koster into Lake Malibu [sic], while Universal's *Between Us Girls* was on location at the resort."

HENRY ALDRICH. Henry Aldrich began as a minor character in the Broadway play *What a Life*, but the "endearingly bumbling kid growing awkwardly into adolescence" spun off into a long run as a radio situation comedy from 1939 to 1953, and he also starred in a dozen movies, beginning in 1939 with Jackie Cooper and ending in 1949 with a television series starring four different actors as the jinxed teenager. The boat scene is from *Henry and Dizzy* (1942) and the footrace is from *Henry Aldrich, Editor* (1942). Both scenes were shot at Lake Enchanto, northwest of Malibu on Mulholland Drive.

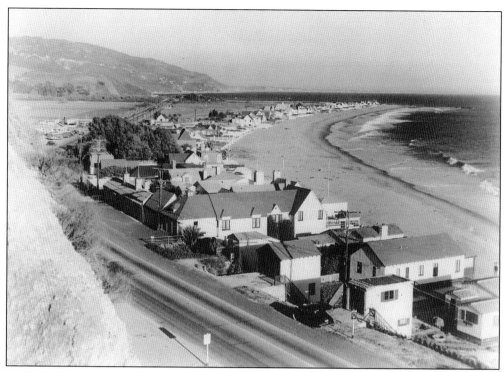

LIFE DURING WARTIME, 1943. This image shows Malibu Colony in 1943 from west to east . . . and a little forlorn. The whitecaps and wave angle suggest winter; a forensic solarologist could say for sure based on shadows. The bleakness could be from the season or because America was deeply involved in wars in the European and Pacific theaters, and every man, woman, and child was involved in the effort.

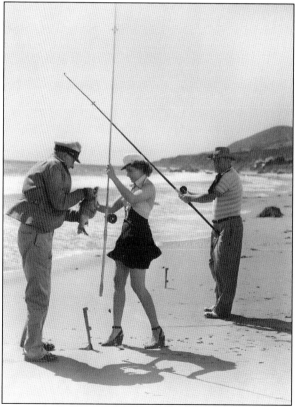

LARAINE DAY. Hollywood's wartime duty was to brighten gloomy times and keep Americans motivated and happy. The caption on this Radio-Keith-Orpheum (RKO) Pictures publicity photograph states the location as Malibu Beach in 1944, and it reads, "GOOD CATCH— Slim Summerville removes a fish Laraine Day [nice gams!] has caught while Edgar Buchanan looks on in this scene for RKO Radio's *That Hunter Girl*, costarring Alan Marshal and Miss Day."

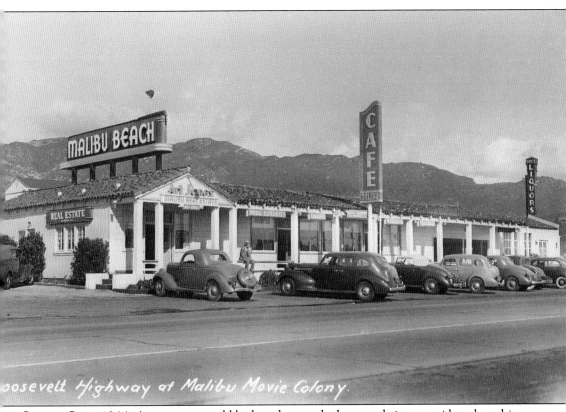

oosevelt Highway at Malibu Movie Colony.

COLONY CAFÉ, 1944. A car expert could look at these parked cars and give some idea when this photograph was taken, and this one looks to have been snapped around 1944. At some point, the Malibu Inn became the Malibu Beach Café, and it is easy to imagine rubes walking into this place and rubbing elbows with the rich and famous from across the road in the colony. The real estate sign is for Art Jones, who was the broker for Malibu Colony for many years. According to Lou Busch Jr., who has a real estate office in Malibu now, the office of Lou Busch Sr. is just out of frame on the old Roosevelt Highway, which is now Malibu Road.

On the Roosevelt Highway, U. S. 101, near Malibu 8A-H3008

MYSTERY HOUSE. What looks to be an isolated west Malibu house toward Point Mugu is actually Latigo Point. The address 26600 Colony Drive is now an empty lot at 26600 Malibu Cove Colony Drive. What once was the Roosevelt Highway are now private roads that do not connect, while Pacific Coast Highway goes inland and around the back of Latigo Point.

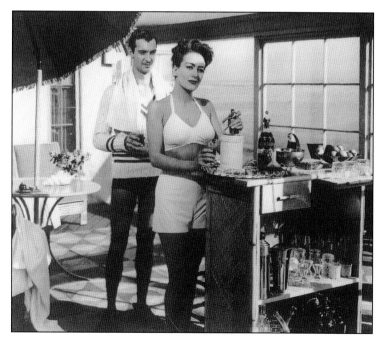

MILDRED PIERCE, 1946. Joan Crawford won the 1946 Academy Award for Best Actress in a Leading Role for her portrayal of determined divorcee Mildred Pierce. Dumped by her husband, her daughters shame her into opening a restaurant. She becomes a successful businesswoman while at the same time having a series of affairs, including one with this chap, Monte (Zachary Scott), who lives at the beach.

60

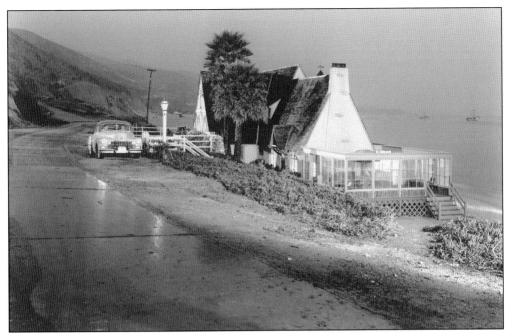

BEACH HOUSE. According to IMDB Trivia, Monte's Beach House was "used in the key opening scene and several others [and] was actually owned by the film's director Michael Curtiz. It was built in 1929 and stood at 26652 Latigo Shore Drive in Malibu. It collapsed into the ocean after a week of heavy storms in January 1983."

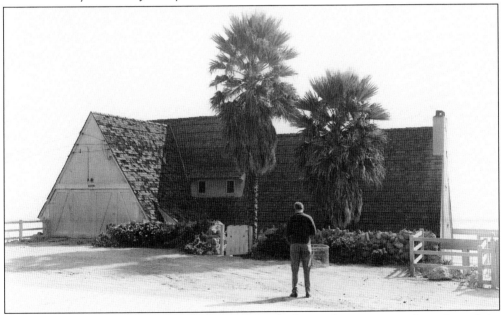

RINDGE'S BEACH HOUSE. Here is an excerpt about the house that is no more from the website Malibu Complete (malibucomplete.com): "Warner Bros. filmed *Mildred Pierce* at that house during December 1944. Originally the Roosevelt Highway [now Pacific Coast Highway], opened in June 1929, followed today's Latigo Shore Drive where Frederick Rindge Jr. built a two-story home at what is now 26652 Latigo Shore."

MYSTERY MAN. This well-dressed man standing at the door of the *Mildred Pierce* home could be a detective, a studio executive, or maybe it is one of the Rindge family's sons. Frederick and May Rindge had three children, Samuel Knight Rindge (1888–1968), Frederick Hastings Rindge Jr. (1890–1952), and Rhoda Agatha Rindge (1893–1962). Perhaps this is Frederick or Samuel making sure those movie people did not wreck an heirloom.

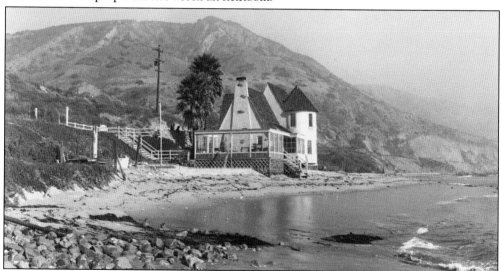

REALLY, THAT IS LATIGO. This image shows another angle of the *Mildred Pierce* house. Hundreds of people who thought they knew Malibu scratch their heads at how much it has changed since 1945. These days, the spot where this house stood is the only empty lot—it separates Latigo Shores Drive from Malibu Cove Colony Drive—as the rest is developed.

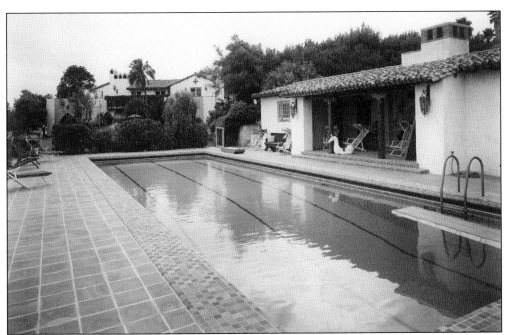

ADAMSON HOUSE, 1946. Hundreds of fancy beachfront houses have been built along the Malibu shore, going back to 1927, but the Adamson House is the mother of all luxury Malibu beach homes. What was known as Vaquero Hill was a land gift from May Rindge to her only daughter, Rhoda Agatha Rindge Adamson, and son-in-law, Merritt Adamson. The Adamson family ran the Adohr Farms dairy and built a pleasure palace overlooking the Malibu Lagoon and Surfrider Beach. Called the "The Taj Mahal of Tile," the beach home is designed with a Mediterranean Revival style and was built by Stiles Oliver Clements. It is bedecked with the very best ceramic tiles from Malibu Potteries. The pool was there for people who did not want to go into the ocean or who wanted to rinse off the saltwater and sun from a day on the beach.

JASCHA HEIFETZ. One of the greatest virtuoso violinists of all time, Russian-born Jascha Heifetz immigrated to America in 1917. He moved to California permanently and married Frances Spiegelberg in 1947. Heifetz was a private man who enjoyed tennis and sailing, so the Malibu Colony was the place for him. These days, former Police bassist Sting is the resident string virtuoso in the colony.

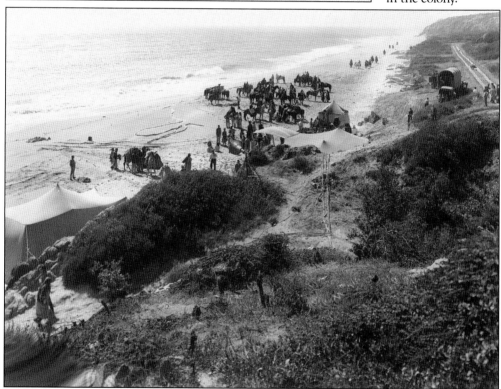

"MALARABIABU." What looks to be a Western film is actually Middle Eastern. The caption of this photograph reads, "FLAME OF TRIPOLI—a troupe of 300, including 100 horsemen, were sent by Universal-International to Sequit Beach, north of Malibu, for the Technicolor production, *Flame of Tripoli*. Setting represents an Arab chieftain's secret encampment." *Flame of Tripoli* was released under the title *Slave Girl*, starring Yvonne de Carlo—later known as "Lily Munster."

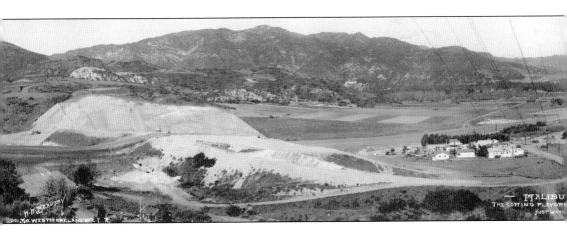

THE COMING PLAYGROUND, 1947. These images show Malibu as it looked in 1947. The population of Southern California boomed after the war, and the impact reached all the way to Malibu. It was still considered the sticks or a weekend place by most people in Los Angeles, but it did become more available to everyone.

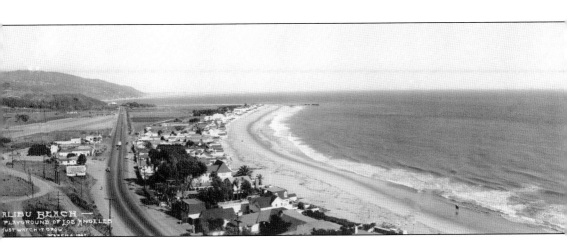

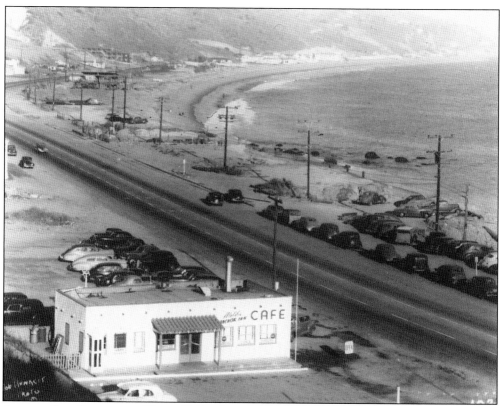

ANCHOR INN EVOLUTION. These 1940s photographs have two views of the scene at the base of the Malibu Pier looking east along Carbon Beach. A forensic "Woodieologist" could hold a magnifying glass to the wood-paneled station wagons and pinpoint the year, but the 1940s is a safe bet. Off in the distance in the photograph above is a split-level building that looked to be an apartment then but is now the Malibu Motel. The vacant lot that is empty above but full of cars below is now the Malibu Beach Inn. Beyond that lot is Carbon Beach before the millionaires came in and walled off that view with their fancy pleasure palaces.

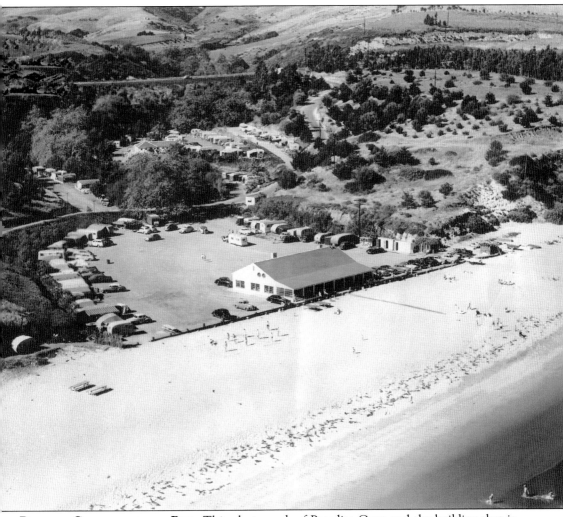

PARADISE COVE BEFORE THE PIER. This photograph of Paradise Cove and the building that is now the Beach Café is dated 1948. However, Bob Morris, whose family owned the property in the 1950s and early 1960s and is the current owner of the Beach Café, believes the image was taken earlier, stating: "The pier isn't showing in this photograph, and I know the construction of the pier was started in 1939 or 1940. . . . There were two guys who owned the property at that time, and I believe they bought the property from the Rindges. To my recollection, the pier was started in 1939 but was halted because of the war, and then it restarted after the war by the next guy who owned Paradise Cove, Bill Swanson."

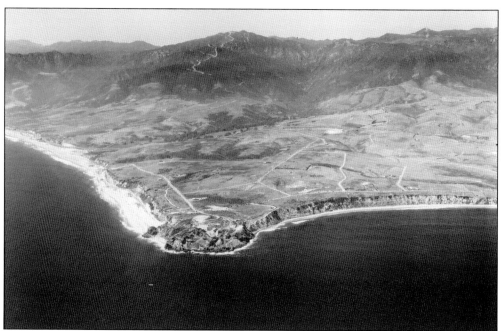

POINT DUME, 1949. Point Dume in the 21st century is one of the most desirable neighborhoods in all of California. Home to the rich and famous, including Barbara Streisand, Julia Roberts, Chris Carter, Hans Zimmer, Bob Dylan, John C. McGinley, and a cast of hundreds. One of the features of Point Dume, beyond the ocean views and the privacy of cul de sacs and secluded beaches, is the variety of flora and fauna along the roads, front yards, backyards, and all over. These aerial photographs were taken in 1949, when Point Dume was being converted from land used for raising cattle and lima beans to subdivisions. It is odd to see that absolutely none of the modern vegetation is native, yet that is the miracle of Southern California—turning barren desert into the Garden of Eden.

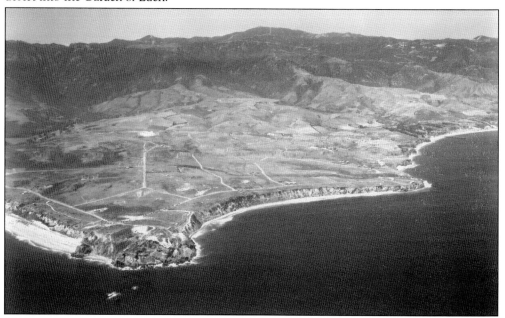

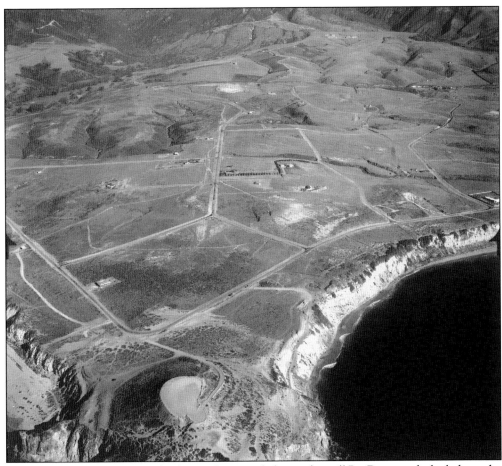

MORE DUME. These photographs show a close-up of what surfers call Big Dume and a look down the coast past Little Dume and Paradise Cove, the Santa Monica Mountains, and most of East Malibu.

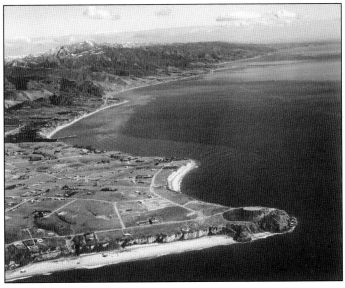

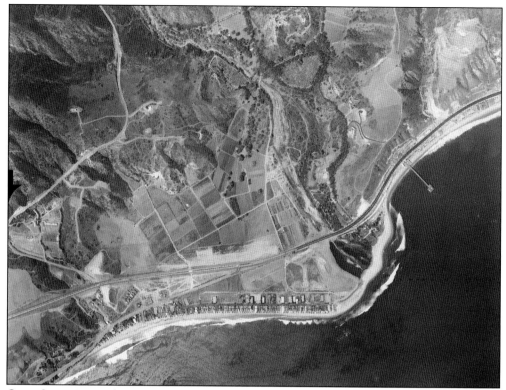

ON A CLEAR DAY. These c. 1949 photographs show the middle of Malibu as seen from directly overhead and looking west to east. On a clear day, one can see all the way to Saddleback Mountain in Orange County, which is about 50 miles away. The image was taken from a World War II bomber equipped with photoreconnaissance equipment.

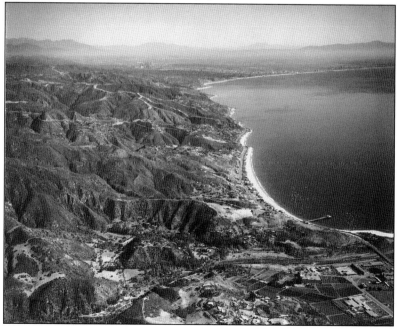

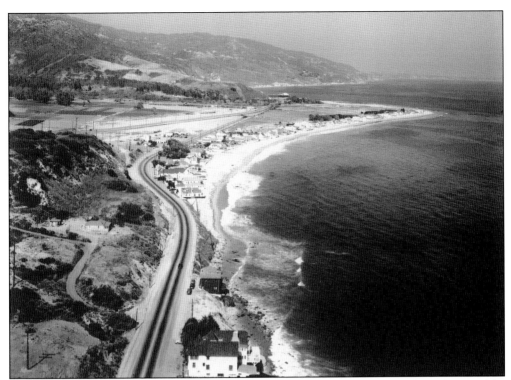

PACIFIC COAST HIGHWAY HEADED EAST, 1949. Following the Pacific Coast Highway from Malibu Colony to Carbon Beach, these photographs show how much Malibu had and had not grown, knocking on the door of the 1950s.

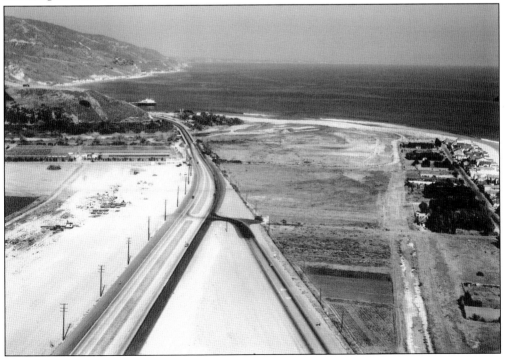

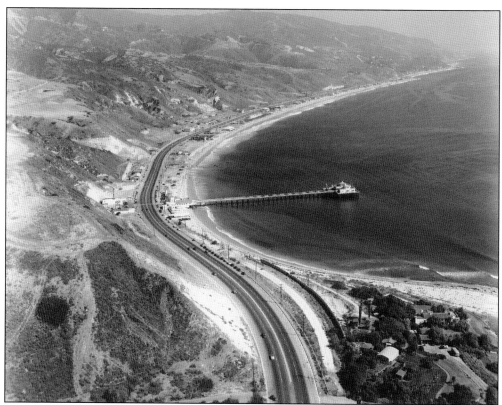

CARBON BEACH, 1949. These photographs look east along the Pacific Coast Highway past the Malibu Pier and toward Carbon Beach. What was mostly empty in 1949 is now lined with spectacular homes owned by the likes of David Geffen, the McCourts, Larry Ellison, Ozzy Osbourne, and many other rich and famous and anonymously wealthy people. What was Carbon Beach has been pressurized into Billionaire Beach.

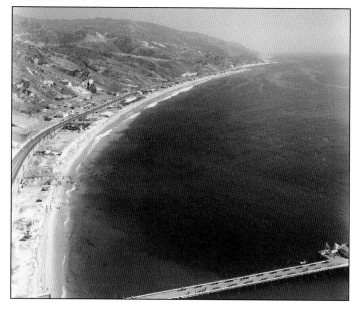

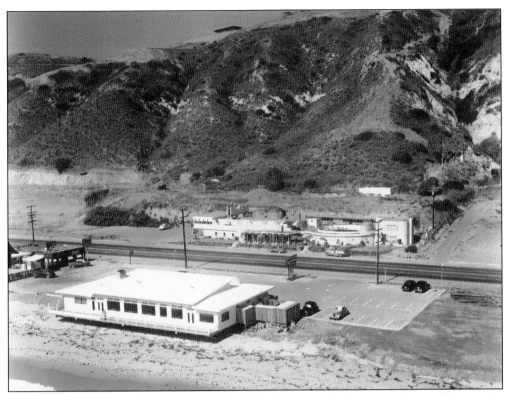

THE SEACOMBER, 1949. Somewhere along the Pacific Coast Highway and toward the end of the 1940s, the Seacomber was another local knowledge stumper. A Google search found an ashtray verifying that it was indeed in Malibu, and Malibu surfer Cary Weiss claimed to have a matchbook from the joint. It was a big mystery until Malibu real estate mogul Lou Busch Jr. saw the photograph. "Sure, the Seacomber," Busch said. "I got sick when I ate there with a bunch of friends. Long gone, but you don't know where that was? That's where McDonalds is now." And he was correct. The Seacomber was where McDonalds is now at 22725 Pacific Coast Highway, just east of the pier and across from where Larry Ellison is converting the Pierview and Windsail Restaurants into a Nobu sushi restaurant.

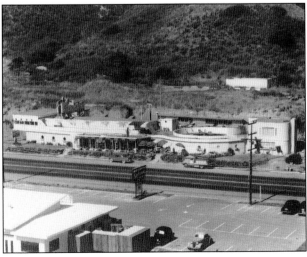

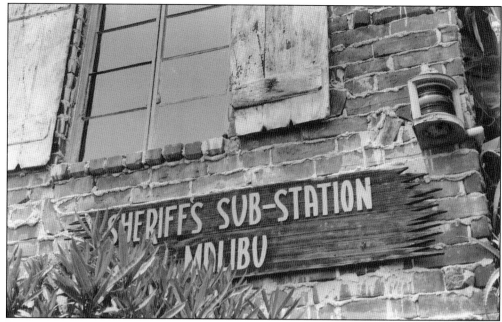

BRICKED CLINK, 1949. Many upstanding Malibu citizens of a certain age blushed at these photographs of the Los Angeles County Sheriff's station for Malibu. They said, "Oh yeah. Do I remember that place." Malibu has not had its own sheriff's station since 2001, when authority over Malibu shifted to the Malibu/Lost Hills Station, just 10 miles and a mountain range away in Agoura Hills. (Lost Hills station was rated highest in the country in the influential Police Stations Visitor's Week 2010 poll.) This building was constructed in 1933 to house the sheriff, but it was also used as the courthouse and a jail, which probably is the inspiration for all the blushing among Malibu citizens who were teenagers or 20-somethings in the 1950s.

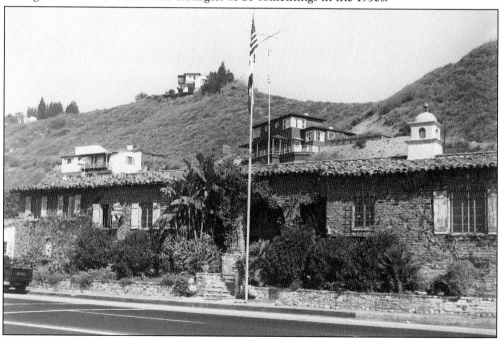

Four

THE GOLDEN YEARS
1950–1959

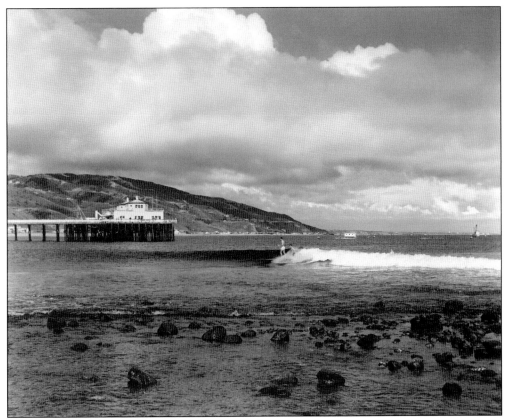

FIRST POINT, 1955. Miki Dora is Malibu's most famous surfer. Born in 1934, Dora hit his 20s in the middle of the 1950s, which were his "Golden Years." For surfers, and Southern Californians in general, the 1950s were a good time. America was a newborn superpower, the economy was booming, and Elvis Presley and Buddy Holly were on the car radio. The family car was hot, and the world was modern enough to be comfortable but not too populated to be uncomfortable. Life was good for civilians and good for surfers. As the squares zoomed by on the Pacific Coast Highway, headed for jobs in the aircraft plants, Dora was part of a "Happy Few" group of surfers who weren't interested in producing much more than adrenaline and surf knots. This photograph of a surfer (possibly Matt Kivlin) on a small wave headed for the Malibu Pier was taken in 1955. This view has not really changed that much, the result of protective city mothers and fathers with foresight and the California State Parks system that has preserved the look of the pier.

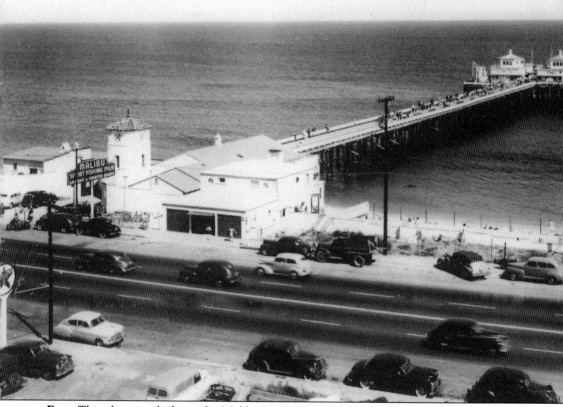

PIER. This photograph shows the Malibu Pier in 1950. This was 45 years after Frederick Rindge started a utility pier and May Rindge finished it to build their railroad, 16 years after the Malibu Pier was opened to the public in 1934, fourteen years after the pier was extended to 780 feet, 12 years after the bait and tackle shop were built at the end, and six years after a storm took out the bait and tackle shop and William Huber bought the pier for $50,000 ($613,000 now). Huber was under the agreement he would build a Coast Guard facility. After World War II, he constructed the twin buildings at the end of the Malibu Pier. Here it is seen open and ready for business.

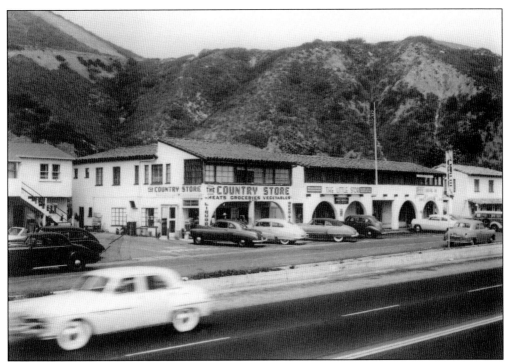

COUNTRY KITCHEN. What is now the Country Kitchen hamburger stand, next to a US post office, the Country Liquor store, the Malibu Dive Center, and other small businesses in the small shopping center, 60 years ago was a small market and café in the area called La Costa between Las Flores and Rambla Pacifica. The flagpole suggests the post office was also there then. This is across from what is now Duke's Malibu.

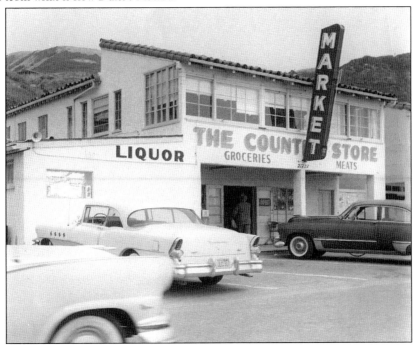

TWO OF A KIND. This Columbia Pictures publicity photograph was taken by "Lippman," which is of no relation to Malibu photographer Steve Lippman. The caption reads, "LOVE DUET—Lizabeth Scott and Edmond O'Brien are a romantic twosome in Columbia's *Lefty Farrell*." Michael "Lefty" Farrell is a gambler who participates in a swindle that goes awry. O'Brien ends up with Scott because they are *Two of a Kind*, which is the title Columbia ended up using.

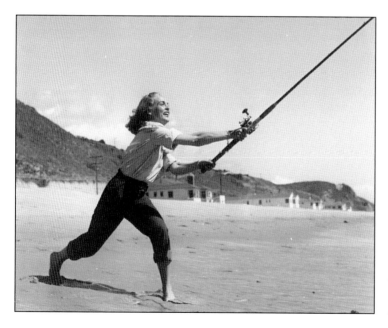

LIZABETH SCOTT. This is good form from an actress who was born Emma Matzo in Pennsylvania in 1922. She came to Hollywood and glammed her name to Lizabeth Scott. Blonde and blue-eyed in the Bacall/Lake genre of femme fatales, Scott starred in 21 pictures from 1947 to 1957—but she is perhaps best known for starring beside Humphrey Bogart in *Dead Reckoning* (1947).

PARADISE COVE, 1951. The current Beach Café at Paradise Cove owner Bob Morris said, "My father bought the property in 1954 to 1955 from Bill Swanson, paying $3,500 an acre [now eight times as much] for the 30 acres up on top. Paradise Cove was another 40 acres for $100,000 down and $15,000 an acre. At the time, Paradise Cove was a sportfishing resort. There was a trailer park [and] boat launching rentals. Where the restaurant is now, three-fourths of it was the recreation room for the trailer park, and one-fourth of it was a small café. When we got it, they had one sportfishing boat. Within two years, we had 50 skiffs, and we were launching 100 to 150 boats a day off the pier. We had the *Betty O*, the *Gentleman*, and the *Del Mar* sportfishing boats, and the *Buccaneer*, a fishing barge that could take a hundred-some people."

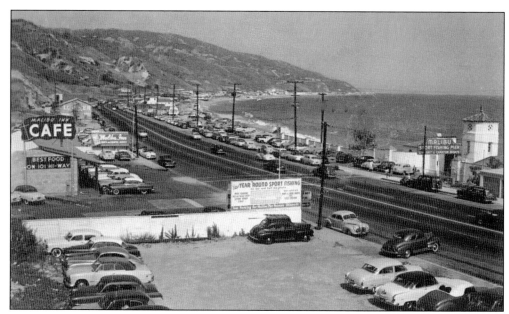

MALIBU INN, 1952. The caption on the back of this Plastichrome postcard, by Colourpictures of Boston, Massachusetts, reads, "MALIBU, CALIFORNIA—Looking south along the Malibu towards Santa Monica—on US Highway 101—near the entrance to the Malibu Pier. The Café on this side of the highway is famous for its many autographed photographs of movie people."

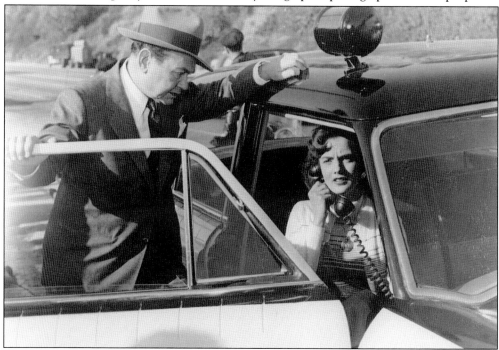

Wow, Boss! Here is a car with a telephone big enough to beat confessions out of suspects! In *Vice Squad* (1952), Edward G. Robinson stars as Captain Barnaby, a hard-edged detective not afraid to bend rules and arms to find the culprits who shot a police officer. Paulette Goddard plays Mona Ross, a madam Barnaby coerces into helping with the investigation.

ADAMSON HOUSE, 1953. The Adamson House was badly burned and nearly destroyed by a fire in 1932. The Adamsons moved in permanently in 1936 with their three children. Merritt Adamson died in 1948, and Rhoda Rindge Adamson continued to live in the house until her death in 1962.

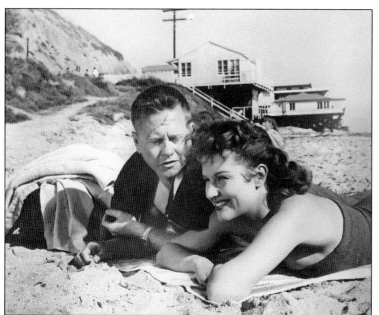

CROOKED ROAD, 1953. Here is Mickey Rooney and Dianne Foster somewhere in Malibu shooting *Drive a Crooked Road* in 1953. Rooney plays a pint-sized auto mechanic with driving skills who is surprised to find a hot dame like Dianne Foster falling for him. The hookup is a setup, as she persuades him to drive two of her friends in a bank heist, and it gets ugly and deadly from there.

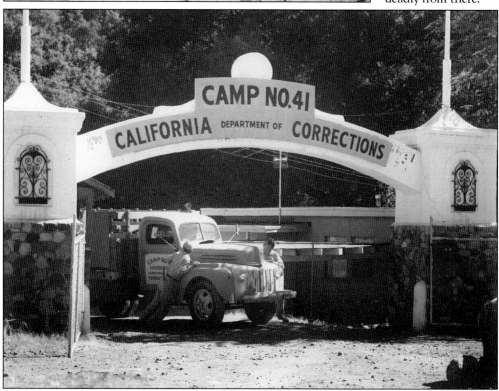

ESCAPE FROM ENCHANTO, 1957. The caption on this Columbia Pictures publicity photograph reads, "BEGINNING OF ESCAPE—Richard Devon and Johnny Desmond begin their bid for freedom by silently pushing a truck through gates of honor camp in Columbia's *Escape from San Quentin*, made by Sam Katzman's Clover Productions." This is the entrance to Enchanto Lake, now across from the Old Place restaurant on Mulholland Drive; the stone pillars remain.

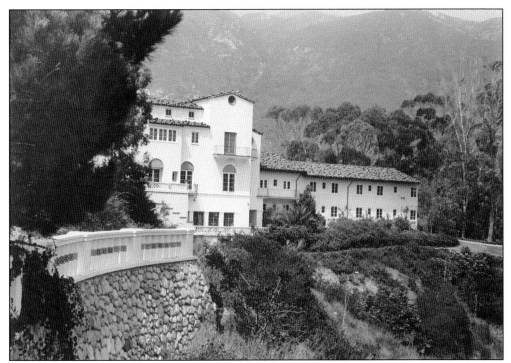

SERRA RETREAT, 1954. This photograph appears to be from a location scout of Serra Retreat, and it was taken from many angles in 1954. As seen from the above angle, it is easy to imagine May Rindge being inspired by the design and location of Hearst Castle. It is also easy to imagine Alfred Hitchcock shooting *Vertigo* on this property, but he chose the Mission San Juan Bautista for those scenes when he shot the movie from 1957 to 1958.

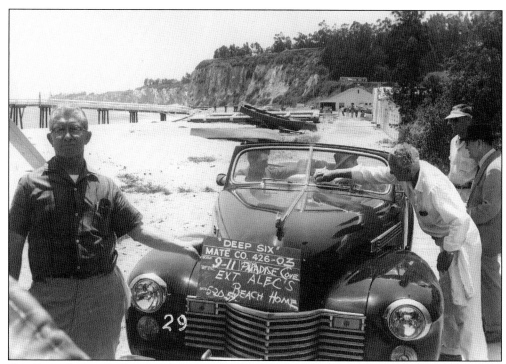

THE DEEP SIX, 1958. Reading between the clapboards, the producers used Paradise Cove both as the beach home of Alec Austen and also a Basque restaurant for *The Deep Six*, a World War II drama in 1958 starring William Bendix, Keenan Wynn, James Whitmore, Efrem Zimbalist Jr., Joey Bishop, and Alan Ladd as Alec Austen, a pacifist Quaker serving on a naval ship who refuses to fire on an unidentified aircraft. The website for Paradise Cove also lists *Gidget, Lethal Weapon, American Pie 2, Sponge Bob Square Pants: The Movie, Monster in Law, Alias, Gidget Goes Hawaiian, How to Stuff a Wild Bikini, Beach Blanket Bingo, The O.C., Charlie's Angels, House of Sand & Fog, Malibu Run, Sea Hunt, Baywatch, Baywatch Nights, Happy Days*, a Chrysler commercial, Budweiser beer commercial, Hummer commercial, Paris Hilton music video, and "thousands of other" television shows, movies, and video productions that were shot at Paradise Cove.

TOPANGA, NEVER FORGET. By 1957, Topango was spelled "Topanga," a private enclave of houses along a popular surf spot. The 1950s were also golden years for Topanga, and it was the home and hangout to a crew of surfing skateboarders, including David and Steve Hilton, Woody Woodward, Bob Feigel, Bill Cleary, George Trafton, and Jim Fitzpatrick. Fitzpatrick said, "Topanga Beach was home to the actors Gary Marshall, Henry Jones, and director Tom Gries, and it was catalyst for the Greebe and Moomy Surf Club and the notorious Topanga Beach Bombers—two of the Saenz brothers, Nicky and Eddie, as well as Jimmy Fitzpatrick, Craig Angell, and Tommy Horner. Not forgetting Norm Ollestad, whose son's survival story following their plane crash has been chronicled in his book, *Crazy for the Storm*." Topanga's golden years ended in the 1970s, when the California Parks Department bought the property. "It was 1973 when the houses started being bull-dozed," Fitzpatrick said. "By August '73, ninety-five percent of the homes were gone."

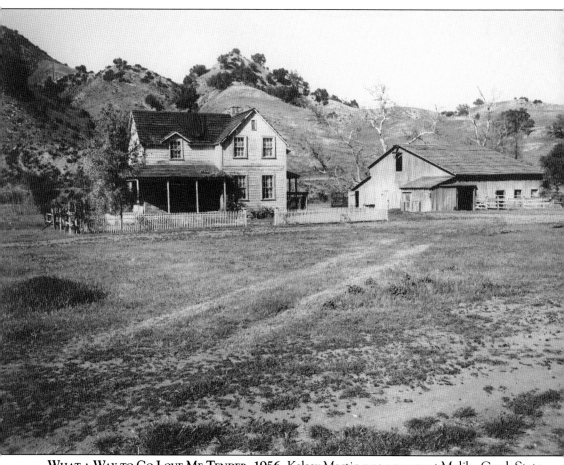

WHAT A WAY TO GO LOVE ME TENDER, 1956. Kelsey Martin was a ranger at Malibu Creek State Park around 2009 and got to know every inch of what was once the 20th Century Fox Ranch. Shown this photograph, she said, "That's awesome! The house is gone. . . the barn is still there. It's Ronald Reagan's old ranch house. The barn is used as a maintenance shop and ranger office now. Where the house was is where all the state cars park. You can see it on the corner of Cornell and Mulholland headed to Malibou Lake." Local historian Brian Rooney begged to differ with that and said it was a set built for *Love Me Tender*, Elvis Presley's first movie, in 1956. However, Mike Malone saw this photograph and disagreed with both of them, claiming this was a set seen in the Shirley MacLaine comedy *What a Way to Go* (1964). Three experts, three opinions, but which one is the truth? Showing them all the photograph again, *What a Way to Go* was the way to go.

20TH CENTURY FOX RANCH, 1958. These are aerial photographs that show Malibou Lake as it looked in the 1950s and an outline of the 20th Century Fox Ranch. What had been the Crags Country Club was bought by 20th Century Fox in the early 1940s after creating an entire Welsh village for *How Green Was My Valley*. Fox considered moving its entire studio to the property but never did. Around this time, Fox Productions filmed *My Friend Flicka* for CBS-TV on its property. A closer look shows what appears to be a giant outdoor movie screen but is in fact the "skypool." Also, the building to the lower left is the dream house constructed for *Mr. Blandings Builds His Dream House* (1948). The house is still there and is used as California State Parks offices.

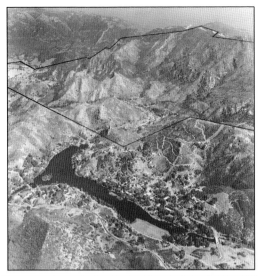

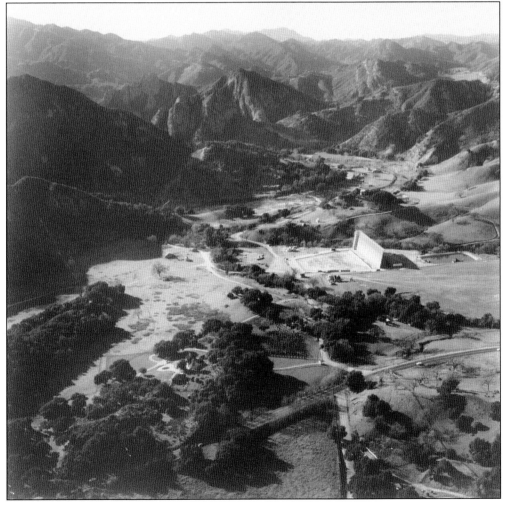

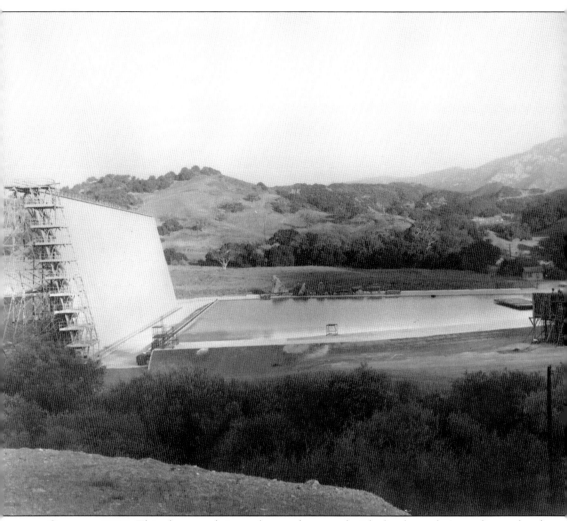

Skypool, 1963. This photograph is up close and personal with the skypool. According to local historian Brian Rooney, the skypool was used for scenes from *Dr. Doolittle* (1967), *Planet of the Apes* (1969), *Tora, Tora, Tora* (1970), *Poseidon Adventure* (1972), and many other television shows and movies using miniatures in a controlled water environment. From Steven Spielberg doing *Jaws* to Kevin Reynolds shooting *Waterworld*, anyone in Hollywood will always say water movies are a pain in the shooting schedule. Driving into Malibu Creek State Park from the access off Malibu Canyon Road, the skypool was located in the field off to the left.

Five

BEACH BLANKET BERSERKO
1960–1980

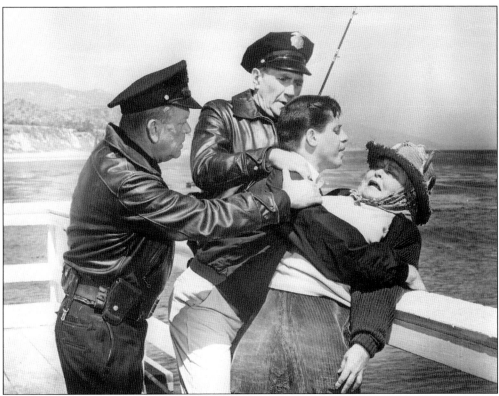

HEY LADY! In 1959, Columbia Pictures invested money and talent to make the movie version of *Gidget*, starring Sandra Dee, Cliff Robertson, and James Darren. The movie looked back on the golden years of the 1950s and effectively ended them. *Gidget* was a big hit that sparked the surfing sensation of the 1960s and brought international attention to the surfing scene on the beaches of Malibu. From there, it became more curious. Where the world had ignored surfers in the 1950s, now there was surf music, surf fashion, surfer slang, and surf movies; some of them actually produced by surfers and others falling into the genre of waxploitation because Hollywood wanted to cash in on the latest fad. Malibu had always been a location for movies, but it usually doubled for other places. Now the movies made in Malibu were about Malibu, and that brought hoards of surfers and gawkers to beaches that had been quiet and empty. For many, the good times rolled in the 1960s, but for others they were the beginning of the end. The police are restraining Jerry Lewis (as Lester) in *It's Only Money* (1962).

WAXPLOITATION FILMS. If *Shaft* and *Superfly* are "blaxploitation" films, then *Gidget* and the 1960s beach and surf movies should be waxploitation films. Another example is *Beach Party* (1963), which was the first of the "Frankie and Annette" movies. This photograph shows Annette Funicello scowling at a swooning beach girl played by Meredith McRae. Miki Dora is just to the right of McRae in the background, and he is culpable for the demise of the golden years for appearing in the waxploitation movies.

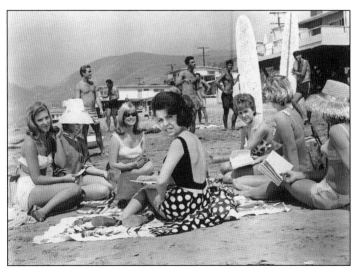

BEACH PARTY TONIGHT, 1963. This is another scene from *Beach Party*. The man standing on the left is John Fain, a famous Malibu surfer from the 1960s. Fain grew up on Malibu Road and still lives there. He was paid $350 a week to work on the Frankie and Annette movies as an extra and also as a stunt man. Back then, that was $2,000 a week—good money for traveling to Hawaii in the winter.

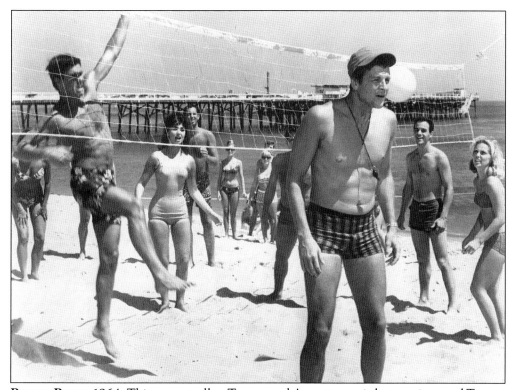

PAJAMA PARTY, 1964. This was actually a Tommy and Annette movie because it starred Tommy Kirk alongside Funicello. The plot involved a Martian who comes to earth and falls in with the beach crowd. Pictured is Jody McCrea as Big Lunk, looking the wrong way during a volleyball match near Malibu Pier.

BEACH BALL, 1965. The American International Pictures (AIP) movies starring Annette Funicello and Tommy Kirk or Frankie Avalon were made fast and cheap but did well at the box office. That inspired imitations, and the best thing about *Beach Ball* (1965) were musical performances from The Supremes, the Four Seasons, the Hondells, the Righteous Brothers, and the Walker Brothers.

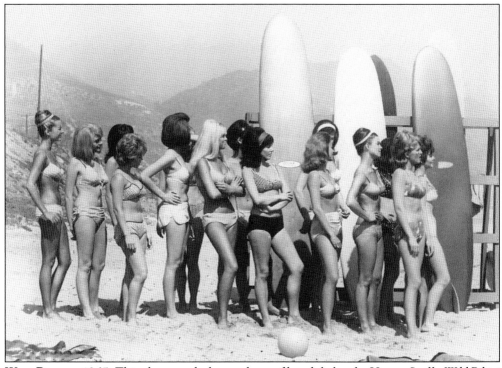

WILD BIKINIS, 1965. This photograph shows a bevy of beach babes for *How to Stuff a Wild Bikini* (1965). This was the last of the AIP waxploitation movies, and it starred Frankie and Annette alongside past and future greats such as Buster Keaton, Mickey Rooney, the Kingsmen (who had the hit "Louie, Louie"), and Elizabeth Montgomery, who would marry series director Bill Asher and go on to star in *Bewitched*.

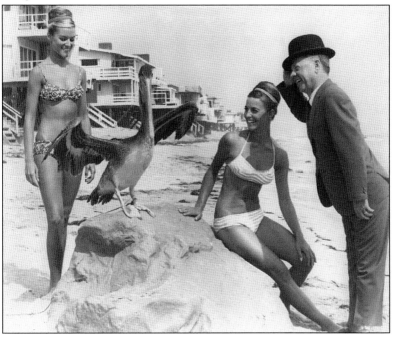

TWO GIRLS FOR EVERY PELICAN. Here is Mickey Rooney on the beach at Malibu with two girls and a pelican. Rooney costarred as Peachy Keane in *How to Stuff a Wild Bikini*.

BIG ROCK, 1966. Not all of the movies shot around Malibu in the middle 1960s were goofy beach comedies. In *Seconds* (1966), Rock Hudson portrays a man who undergoes a physical transformation to start a new life as a new person, complete with a house on the beach in Malibu. This beach home actually belonged to John Frankenheimer, who directed the movie.

MISTER BUDDWING, 1966. James Garner (left) plays Mr. Buddwing, who wakes up in Central Park with no memory and only a few clues as to who he is. He wanders around New York City trying to string together his identity. Apparently those clues, or maybe memory flashbacks, lead him to the beach in Malibu.

GIRLS AND GUITARS, 1966. Strangely, this is pretty much what Malibu beach is like now—a pretty girl dancing the Frug, kids making out, and at least three electric guitars playing at any time—without electricity or speakers. Actually, this is a scene from a truly cheap, bad, and nonsensical horror movie called *The Wild Wild World of Batwoman* (1966).

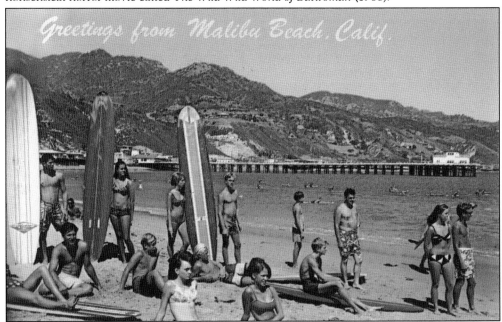

BEACH SCENE. All of the waxploitation surf and beach party films of the 1960s were based on a real Malibu surf scene. During the 1960s, Surfrider Beach at Malibu was one of the centers of the surfing universe. Famous surfers like Miki Dora, Dewey Weber, and Johnny Fain used the perfect waves to push surfboard design and surfing performance out of the 1950s and into the future.

OCEANFRONT RESTAURANTS, 1965. Sometime in 1965, the Fox Location Department apparently needed an oceanfront restaurant for a movie or television show. It scouted everything available along Pacific Coast Highway (PCH), from Sunset Boulevard up to Trancas, and it left behind views of the dining possibilities in Malibu in the middle of the 1960s.

PCH AT COASTLINE. Ted's Rancho Restaurant is no more, but in the 1960s it was where Coastline Drive and Pacific Coast Highway met. An empty lot stands there now, just below the Getty Villa.

THE POINT. Interestingly, the location scout who labeled this photograph wrote "So. of Topango Canyon," which shows the masculine form of what is now called Topanga was still in use in the 1960s. The Point was in the 1960s where the Chart House is now, just south of Topanga Canyon Road.

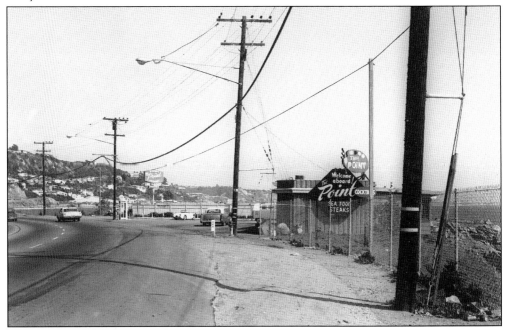

SEA LION INN. Where Las Flores Road meets PCH, the Sea Lion Inn is now Duke's Malibu, and the Albatross hotel and restaurant is now a dirt lot next to a 76 gas station. According to a 2010 *Malibu Times* article about Malibu ghosts, "Legend has it that Chris 'the Captain' Polos bought Las Flores Inn in 1944, turned it into Duke's precursor The Sea Lion, and worked at the restaurant daily until he died at age 99 in 1986. Supposedly, the workaholic captain still fusses over the bar in spirit." Duke's opened in 1996.

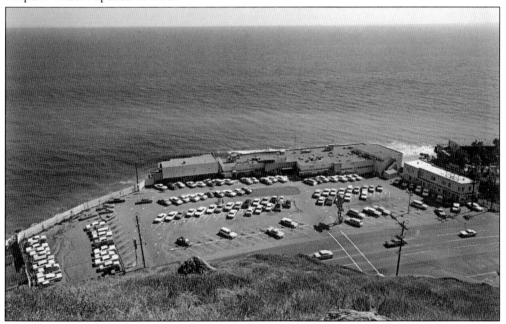

LAS FLORES AT PCH. The Sea Lion Inn burned almost to the waterline in November 1964, but owner Chris Polos made good on his vow to rebuild. Duke's Malibu opened in July 1996 and brought Hawaiian-style food, drinks, and service to the mainland. Duke's suffered serious flooding during March 2011, but the beloved business recovered fast.

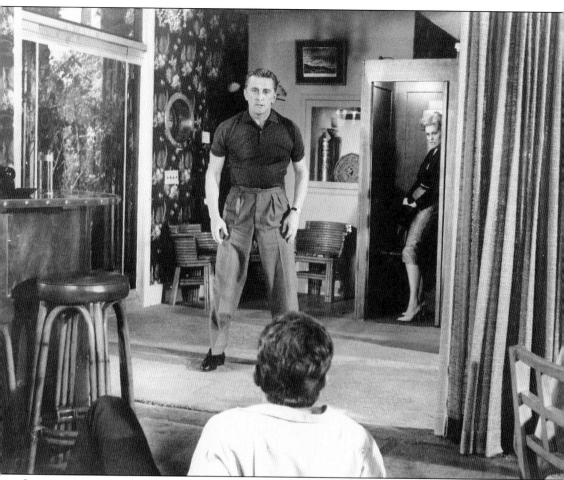

SHOWDOWN AT THE ALBATROSS. In the film, *Strangers When We Meet* (1960), Kirk Douglas plays architect Larry Coe, a family man who has an affair with family woman Kim Novak, as Maggie Gault. This scene of what appears to be a fistfight also appears to be an illicit tryst. The movie used the Albatross as a location, perhaps because of its reputation as a cathouse.

TONGA LEI RESTAURANT AND MOTEL, PACIFIC COAST HIGHWAY, 1965. A menu found online, called the "Grog List," for the Tonga Lei Polynesian restaurant offered "medium," "strong," and "communal" mixed drinks starting at $1.60 for a Hawaiian Sunset to $2.25 for a mai tai and $2.50 for a Suffering Bastard or Pele. It went all the way up to $3.75 for a Cherry Blossom; however, one has to multiply the price times six for modern equivalents. A mai tai in the Beach Bar at Duke's now costs $7.50.

PRE-GLADSTONES. Although this photograph is a little out of sequence, the 1965 location of the Sea Shore Inn was a mystery until Bob Morris from the Beach Café at Paradise Cove took a look at these photographs and knew this one immediately. The Sea Shore Inn was at the bottom of Sunset Boulevard where it meets PCH, where Gladstone's is now.

PRE-STARBUCKS. This is the Trancas Market and Restaurant photographed by the 20th Century Fox Location Department on September 7, 1965. What was the market is now a Starbucks, and the larger How's Market opened to the right of this photograph in the 1990s. How's closed abruptly in August 2011.

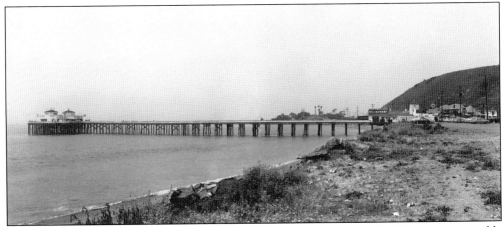

PIER, 1966. On May 18, 1966, the Fox Location Department scouted the Malibu Pier as a possible location. Standing next to Tonga Lei, in the lot where Malibu Beach Inn is now, the pier as seen from the east does not look much different than today.

SURFRIDER BEACH. This angle looking west from the pier is a little different now because the fixed lifeguard tower that was there in the 1960s has been replaced by two mobile towers, which Los Angeles County's finest moved around due to season, sand movement, and erosion.

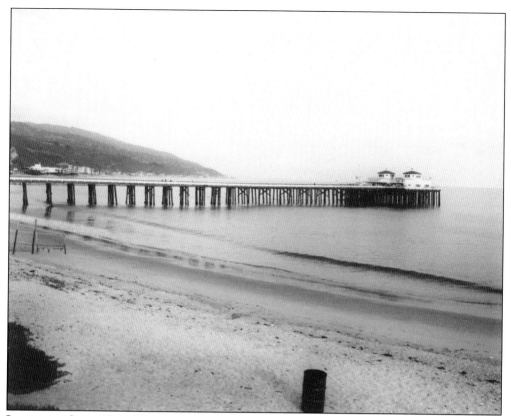

Looks the Same Now. This angle of the Malibu Pier, taken from the west side in 1966, looks exactly as it does now. The author of this book often parks along PCH and walks down to the water's edge, taking in this view exactly.

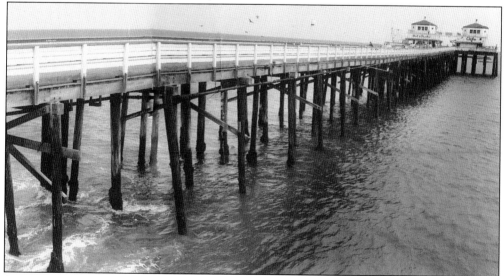

Shooting the Pier. The California State Parks Department bought the Malibu Pier for around $3 million in 1980. It has invested a great deal of time, money, and man-hours into restoring and preserving the pier, keeping it looking exactly as it did in the 1960s and before.

KING KONG GATES. Taking a stroll from the base of the pier and out to the end and back, this view looks through what former Malibu mayor Jefferson Wagner calls the "King Kong Gates." The big ape movie starring Fay Wray came out in 1933, and the pier opened to the public in 1934, so the name could date back to that era.

THIS IS THE END. In 2011, the bottom of the west building is a Ruby's Shake Shack with the office of Baywatch Malibu on the west side of the west building. There is a gift shop in the lower east building and also the headquarters for Malibu Sportfishing. The upstairs is empty . . . and would be a great place for a Malibu history museum.

REVERSE ANGLE. In cinematography, this is called a "reverse angle" because it looks from the end of the Malibu Pier and back toward the King Kong Gates. As this book was being written in June 2011, the pier almost burned down when a dropped cigarette ignited bird feathers and then the creosote-soaked timbers. This happened a few feet from the lifeguard headquarters, and the lifeguards brought the Baywatch boat back from Zuma at flank speed to hit the flames with their water cannon until Los Angeles County firefighters could run hoses to the end of the pier.

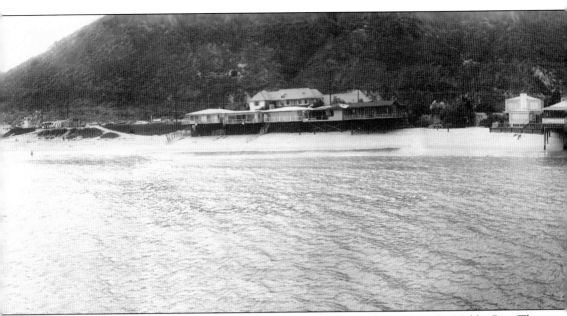

PAN-A-VISION. This is a Widelux view looking northwest by northeast from the Malibu Pier. The long building on the other side of PCH to the east of the Malibu Pier was the original train house for the Rindges' private railway. It was an indoor lumber store and other many things until the 1970s, when it was torn down and replaced by a modern office building. The Tonga Lei restaurant

was replaced by Don the Beachcomber and then later by the Malibu Beach Inn. The house on the east side of the pier across PCH is now owned by Chabad of Malibu. The house on the cliff above and to the east of the pier burned down in the 1990s. Presently on the lot there is a spectacular, $13-million architectural masterpiece, designed by Jay Vanos, called the Wave House.

COMES A HORSEWOMAN. Malibu was still rural and "hippie" enough in the 1960s that horseback riding on the beach was not a federal offense. These days, body boards and kayaks are not allowed in the surf at Surfrider, smoking is illegal on the beach, and even dogs are not allowed. These days, a horse rider passing from Surfrider under the pier to Carbon Beach would probably inspire a posse.

BIKINI BUNNIES BUSTIN' OUT. *It's a Bikini World* is part of the waxploitation genre. The tagline to this movie is "the Bikini-Bunnies are Bustin' Out All Over!" Oh behave! The plot has a playboy named Mike Sampson (Tommy Kirk) trying to lure a young feminist named Delilah Dawes (Deborah Walley) into his harem. Delilah wants nothing to do with Mike, so he pretends to be his nerdy brother Herbert. But Mike/Herbert falls in love with Delilah, and he must reveal his secret without blowing the deal.

THE OLD PLACE. This small country store in 1967 is now the Old Place, a very cool little restaurant run by Morgan Runyon, the son of the original owners. Runyon is also a Malibu local who helped identify some of the real mysteries in this book. Looking at these two photographs, Morgan said, "Yeah, that's the old place before it was the Old Place. It's Hank's country store and the Cornell post office. The false front was added by my dad around 1969. Mail sorting boxes still exist in the back room. Stop on in!"

"Frankie" Goes to Malibu. In 1968, Frank Sinatra starred with Jacqueline Bisset in *The Detective*. Sinatra played detective Joe Leland, who was investigating the murder of a homosexual and uncovers a web of deceit and corruption. *The Detective* is another movie set in New York City but somehow ended up on the beach at Malibu. Mia Farrow was supposed to costar with her husband, Frank Sinatra, in the movie, but she was caught up in another movie and refused. Sinatra became so angry, he served his wife divorce papers on the set of *Rosemary's Baby*. There is more trivia about the movie: *The Detective* was based on a book by Robert Thorp, and the sequel to that book, *Nothing Lasts Forever*, has detective Joe Leland trapped in a skyscraper after it is taken by German terrorists. In the film, he must also rescue his daughter and grandchildren. Sound familiar? *Nothing Lasts Forever* was made 20 years later under the title *Die Hard* with Bruce Willis.

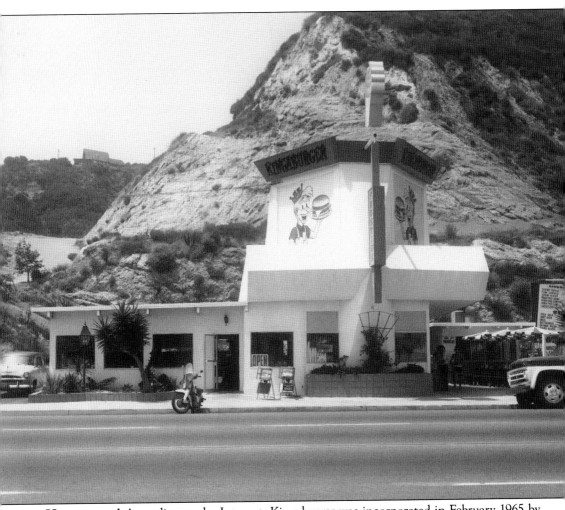

Hamburgers! According to the Internet, Kingaburger was incorporated in February 1965 by William Maben with one location at 18002 Pacific Coast Highway. That address would place this hamburger stand east of Chart House, but those who know Malibu would recognize this building as what is now Budget Rent Car, just east of the Malibu Pier. Kingaburger might have been a play on Dairy Queen, but it did not morph into Burger King, and apparently this was the only one. As this caption was being written, Malibu resident Curtis Beck saw the photograph and exclaimed, "Did I eat there? I lived up Sweetwater Mesa, that road in the background. Oh yeah, I ate there as a kid. That place was horrible." Jefferson "Zuma Jay" Wagner added that after Kingaburger this became a restaurant called the Wine Cellar.

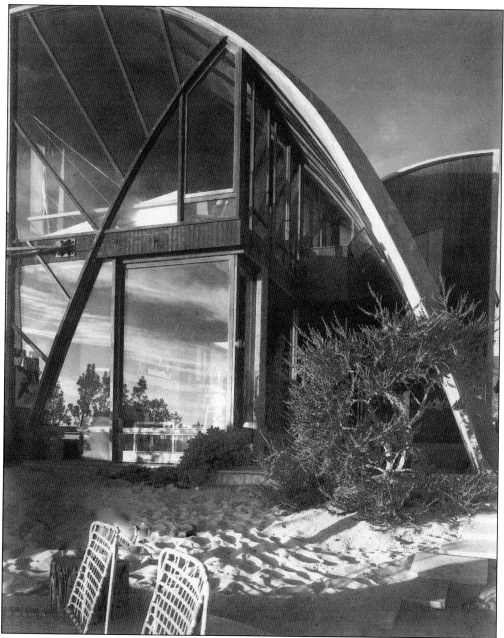

THE STEVENS HOUSE. The Adamson House, built in 1930, might have been the mother of all fancy Malibu oceanfront properties, but many fancy offspring have appeared along the 23 miles of scenic beauty since then. In 1968, John Lautner built this arched, wave-inspired home in Malibu Colony for Dan Stevens and his family. Born in Michigan in 1911, Lautner was a protégé of Frank Lloyd Wright and moved to Los Angeles in 1937. He designed and redesigned dozens of homes, businesses, and other structures over the next 60 years and up to 1992. The Stevens House is considered "architecturally significant" in the evolution of Malibu beach homes, and it still stands in Malibu Colony.

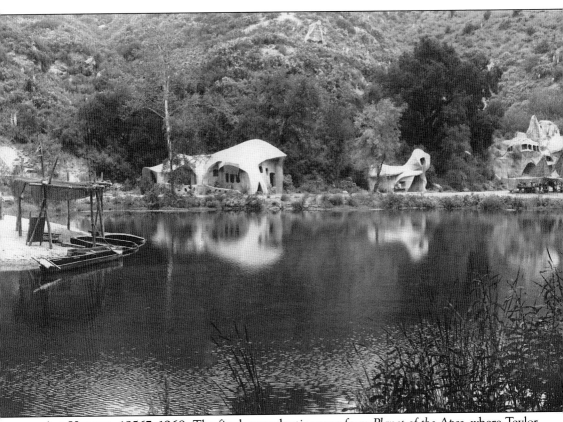

Ape Village, 19567–1968. The final, apocalyptic scene from *Planet of the Apes*, where Taylor (Charlton Heston) sees a fragment of the Statue of Liberty protruding from the sand, was filmed along a secluded cove between Westward Beach and Point Dume. The small ape village where Taylor is taken as a prisoner was built along Malibu Creek in what was still the 20th Century

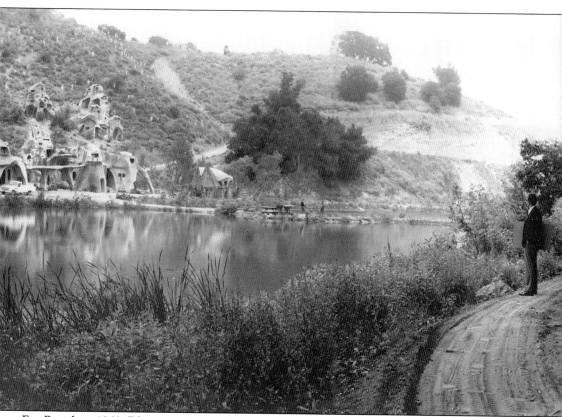

Fox Ranch in 1968. Filming took place between May 21 and August 10, 1967. *Planet of the Apes* was a significant hit and launched a franchise that is still resonating today with the release of *Rise of the Planet of the Apes* in 2011.

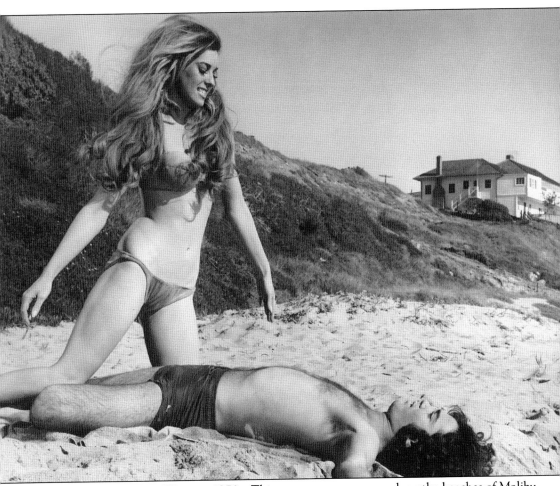

ATTACK OF THE BIKINI WOMAN, 1970S. This was a common scene along the beaches of Malibu from the 1960s into the 1970s—liberated, lust-crazed women wearing next to nothing, attacking defenseless men in broad daylight on beaches from Topanga to Broad Beach. . . well, sometimes that happened. This is a scene from *Beyond the Valley of the Dolls*, directed by Russ Meyer and written by Roger Ebert. The movie received an "X" rating and became a Hollywood legend. The woman in this photograph is Edy Williams, who played Ashley St. Ives in the movie and went on to marry director Russ Meyer shortly after it was released. Her helpless victim is unidentified.

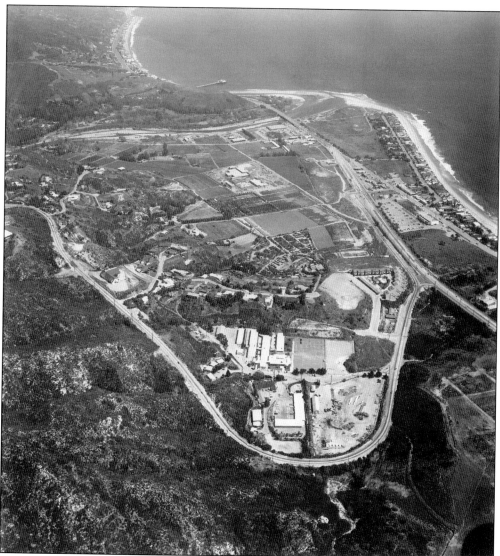

PRE-PEPPERDINE. Here is an aerial view of Malibu in the years just before Pepperdine College moved in. Pepperdine was founded in South Central Los Angeles in 1937 and was fully accredited by 1938. Founder George Pepperdine had made a fortune with Western Auto Supply. He started with $5 and ended up with enough money to endow a college with two goals, saying, "First, we want to provide first-class, fully accredited academic training in the liberal arts. . . . Secondly, we are especially dedicated to a greater goal—that of building in the student a Christ-like life, a love for the church, and a passion for the souls of mankind." By 1965, the neighborhood around Pepperdine had deteriorated to the point that the college was almost burned to the ground in the Watts Riots. In 1967, the Adamson-Rindge family, in the spirit of Frederick Hastings Rindge, offered 130 acres of land overlooking Malibu to the university. The university broke ground in April 1971, and the campus opened in September 1972.

ROCKY. *The Rockford Files* costarred Noah Berry Jr. as Joseph "Rocky" Rockford, the father of Jim Rockford, a raggedy private detective who charged $200 a day plus expenses and handled mostly cold cases in order to not anger the cops. Rockford barely made enough money to live in a raggedy trailer on the beach at Paradise Cove. *The Rockford Files* was a popular show that ran from 1974 to 1980. It is a fun show for Malibu citizens to watch now, as there are long scenes and frequent glimpses of how Malibu looked 30 years ago.

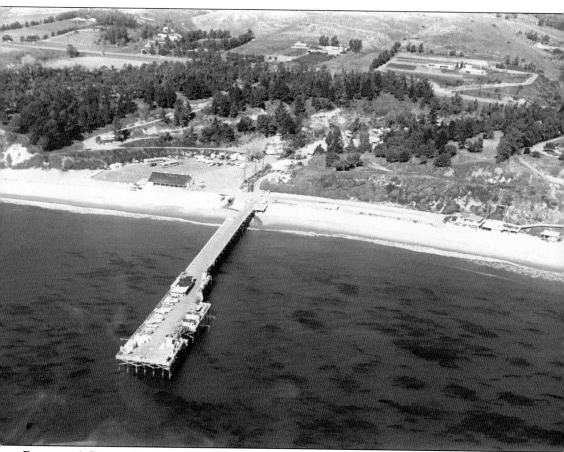

ROCKFORD'S BEACH. Speaking of Rockford, Paradise Cove is where the defamed detective barely got by in his beach trailer. This is how it looked in 1968, and it was not much different into the 1970s. Beach Café owner Bob Morris said, "My father sold the property in 1964 to 1965. We had it 10 years, and I think my dad got millions for it. That allowed him to buy a boat and live a life of leisure. I, on the other hand, had to go to work." Bob Morris had a hand in building and managing many Malibu restaurants, including Gladstone's Malibu, the Jetty, RJ's the Rib Joint, and Malibu Sea Lion. In 1988, he returned to Paradise Cove to run the Beach Café, which became a booming establishment. "To this day," Morris said. "People come to the Beach Café and ask if they can stand where Rockford's trailer was, [especially] a lot of Japanese people. I guess that show was popular in Japan." Strangely, James Garner now lives across the street from Bob Morris.

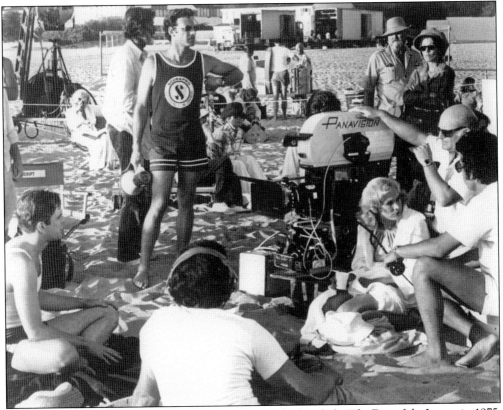

HOLLYWOOD EXPOSÉ. This photograph was taken on the beach for *The Day of the Locust* in 1975. An all-star cast, including Donald Sutherland, Karen Black, and Burgess Meredith, brought to life the Nathaniel West novel, a 1930s-era indictment of the seamy underside of Hollywood. *The Day of the Locust* received two Academy Award® nominations.

B-MOVIE. This photograph is a riff on the classic dog-pulling-bathing-suit Coppertone scenario, and it was taken at Malibu Beach for a 1978 B-movie ("B" as in beach movie). The movie poster shows a dog with a bikini top in its mouth looking at a woman, who has lost her top and is seen from behind. The plot of *Malibu Beach* involves a female lifeguard who gets involved in a love triangle with two beachgoers.

MOMENT BY MOMENT, 1978. One can tell by the way he walks that this is the "John Travolta Strut," as seen on the Malibu Pier in 1978. The caption on the back of this publicity photograph from Universal Studios reads, "Trisha (Lily Tomlin), a married woman, and Strip (John Travolta), a young drifter, are two people with different life styles who meet casually and fall in love in *Moment by Moment*, the romantic drama written and directed by Jane Wagner. A Universal release."

PRIVATE ENTRANCE. A forensic muscle-car expert could explain it better, but that looks like the front end of a 1968 Thunderbird, a Pontiac convertible, and an Oldsmobile at the entrance to Malibu Colony. This is the late 1960s and early 1970s, which is over 40 years after May Rindge began leasing Malibu Colony lots. To the left is John Lautner's Stevens house. In the 1970s, the colony was the home and hangout for Larry Hagman, Diane Cannon, Neil Diamond, Joni Mitchell, and various members of the Rolling Stones.

Six

Malibu Is
Stranger than Fiction
1981–2011

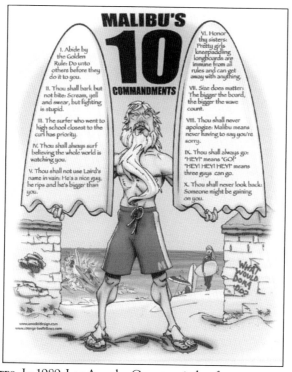

Malibu Incorporates. In 1989, Los Angeles County tried to force a sewage system into Malibu, which was still an unincorporated part of Los Angeles County. The citizens of Malibu knew that the sewage system would allow unlimited growth but would destroy the rural, underpopulated, and aesthetically uncluttered California Riviera they had grown to love. The citizens of Malibu worked together, took a vote, and decided on becoming a city that would manifest its own destiny. The city of Malibu celebrated 20 years of cityhood during the winter of 2010 and 2011, and citizens reflected on how slowly the city had grown in relation to all the urban density around it. In retrospect, it was a visionary decision, because Malibu's population density of 620 people per square mile is 6 to 10 times less dense than the county and city of Los Angeles. Malibu is a special place to live because it is between the Santa Monica Mountains and the deep blue sea. Yet it is also an odd place, as seen in this collection of photographs. (Illustration by Ariel Medel.)

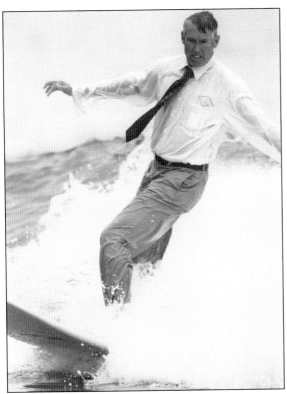

EVERYBODY SURFS. It is not entirely true that everyone in Malibu surfs, but the mayor does. This is Jefferson "Zuma Jay" Wagner, preparing for a city council meeting during his nine-month reign as mayor, which began in April 2010. A longtime environmentalist, Jay was part of a city council that banned most plastic bags and smoking on the beach within the city of Malibu. (Courtesy Lucia Griggi.)

LAGOON RESTORATION. In 2011, Malibu became embroiled in an uncivil, green-on-green war in a debate over whether or not to bulldoze the Malibu Lagoon to restore it or leave it alone. As a city council member and a surfer, Zuma Jay stood on one of the bridges that restoration would have taken out while being interviewed by "anti-restorationistas" Marcia Hanscom, Mr. Malibu, and Andy Lyon. (Courtesy Ben Marcus.)

SURFAGENARIAN. The regular crew of surfers at First Point Malibu is as colorful as the birds in the lagoon, and members also can be a bit loony. This is George "Mysto George" Carr, an 80-something "surfagenarian," who is at Surfrider Beach every day. He is staying young in the surf and keeping his mind sharp by beating everyone at chess on the tailgate of his Honda. (Courtesy Ben Marcus.)

HOT CAR. Malibu is famous for being famous, but it is also known for fires, floods, and landslides—but there are no plagues of locusts yet. Malibu nature is 98 percent benign, but when the Santa Ana "Devil Winds" flare up, the hills catch fire and all hell breaks loose. Fire is harmful to people, animals, and other things caught in the path. (Courtesy Ben Marcus.)

MALIBU KITCHEN. From fast food to five star, Malibu offers a variety of cuisines. This photograph shows Bill Miller, owner of Malibu Kitchen, in the Malibu Country Mart. A transplanted New Yorker, Miller brings New York flavors to Malibu. His place is popular with citizens and tourists, including Jerry Seinfeld, who often pulls up in one of his Porsches for an H&H bagel. (Courtesy Ben Marcus.)

THE OLD PLACE. Take Malibu Canyon Drive, turn west on Mulholland, and go about five miles back in time to the Old Place. A little bit 19th century and a little bit rock and roll, the Old Place has expanded its menu from steak, clams, baked potatoes, and sourdough bread (which sounds pretty good right now). The Old Place is now serving a garden of earthly delights. (Courtesy Bryan Rooney.)

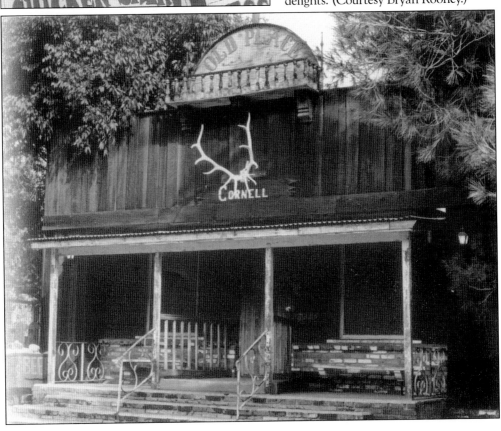

MODEL SHOOT. This is the sort of thing one expects to see while walking on the beaches of Malibu. In the middle of winter 2010, English and Italian photographer Lucia Griggi lined up locals Allison, Ana, Kelsey, and Lynn for a modeling shoot on Westward Beach. The weather was cold, but the girls heated it up. (Courtesy Ben Marcus.)

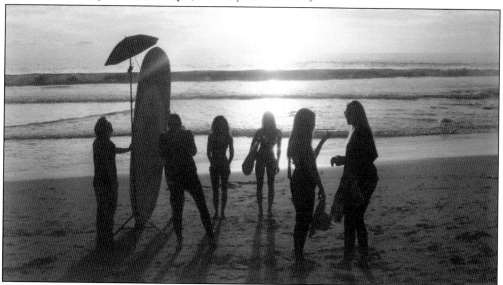

SUNSET SILHOUETTE. This modeling shoot was located in front of the Sunset Restaurant, a great place to get a drink, eat dinner, and watch the sun end another day by extinguishing itself in the Pacific Ocean—cuing The Eagles' "Hotel California" or "The Last Resort" will do. Fade to black. (Courtesy Ben Marcus.)

DISCOVER THOUSANDS OF LOCAL HISTORY BOOKS FEATURING MILLIONS OF VINTAGE IMAGES

Arcadia Publishing, the leading local history publisher in the United States, is committed to making history accessible and meaningful through publishing books that celebrate and preserve the heritage of America's people and places.

Find more books like this at
www.arcadiapublishing.com

Search for your hometown history, your old stomping grounds, and even your favorite sports team.